Chihuly Glass

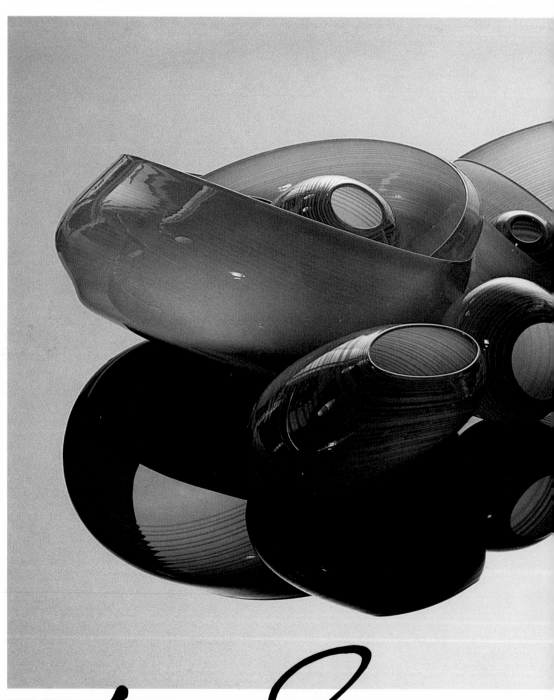

Dale Chihuly

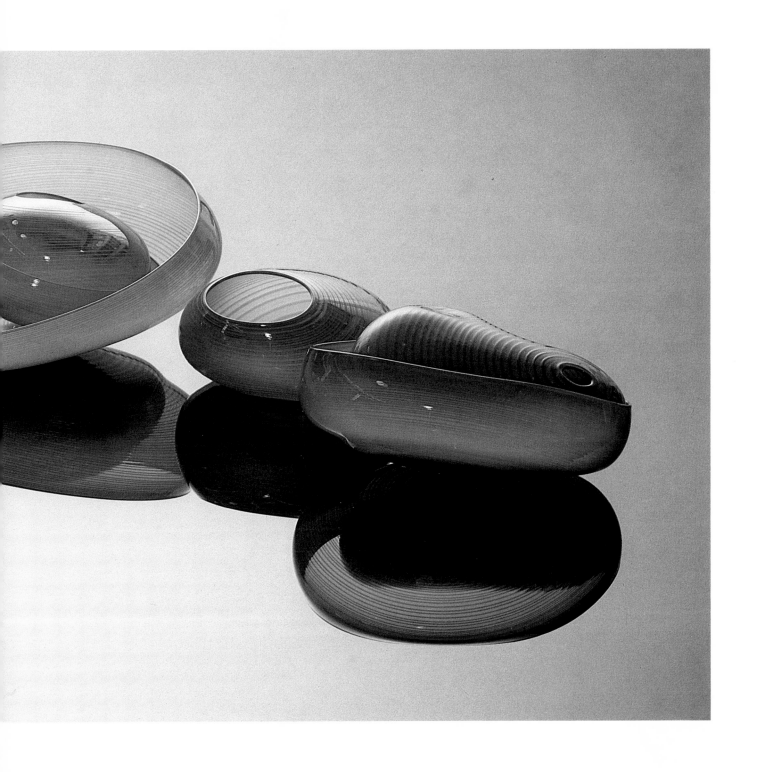

Glass Introduction by Linda Norden

For My Mother

Designed by

Malcolm Grear Designers

Type Set by

Dumar Typesetting, Inc.

Color Separations by

National Bickford Graphics

Printed on

Northwest Quintessence

by

Foremost Lithograph Co.

ISBN 0-9608382-0-1

Library of Congress

Catalogue Card Number: 82-71496

I would like to thank all my friends from the cooks to the gaffers who made the glasswork in this catalogue possible.

My gratitude also to the following people for their tireless efforts from the concept to the finished catalogue: Skip Bickford, Angela Bucci, Malcolm Grear, Diana Johnson and Linda Norden.

Dale Chihuly

I want to thank all of Chihuly's friends, students, teachers, and fellow artists who were so generous with their time. The following people, whom I managed to reach either in person or over the telephone, deserve special mention for their patience in answering my wide-ranging questions—without their assistance I could never have written this essay: Todd Boli, Doris Brockway, James Carpenter, Viola Chihuly, Charles Cowles, Russell Day, Kate Elliott, Frances Hamilton, Paul Hollister, Roni Horn, Hardu Keck, Alain Kirili, Pamela Kuehl, John Landon, Jack Lenor Larsen, Michael Lawson, David Manzilla, Michael Monroe, William Morris, Abe Rothblatt, Italo Scanga, Rose Slivka, Barbara Vaessen, Joan Wolcott, and Mary Zynsky.

Lastly, I would like to thank my husband, Will Joyner, for discussion and editorial assistance; Diana Johnson for the final editing; and, of course, Chihuly himself.

Linda Norden

Perhaps at forty, after almost twenty years of pushing forward, Dale Chihuly can afford to satisfy a bit of the retrospective urge by taking stock and examining the evolution of his work. The paradox that is Chihuly — an ardent proponent of collaboration who must, in the end, direct; a worker whose greatest luxury consists in the freedom to travel where and when he wishes; a hard-driving man, generous and honest, yet disarmingly inaccessible — can only be understood as a complex amalgam, as elusive as his forms are direct.

Whereas in the past each new Chihuly series was heralded for some distinct innovation, the more recent work, the sea and shell forms, resonates with echoes of earlier concerns. If only because of its persistent quality, Chihuly's work begs for some sort of chronological assessment, some acknowledgment of both consistency and development.

One could point out that shells have long symbolized a capacity for synthesis and renewal, but Chihuly has never been one to use his pieces as conscious symbols or allegories. Still, his new work achieves more completely what has always been present to some degree — the bringing together of a number of concerns deriving from both his early training in architecture and weaving and his later explorations of the properties unique to glass.

As it happened, Chihuly's first encounters with glass took place within the context of a weaving assignment at the University of Washington. Asked to incorporate some non-fiber material in a work, Chihuly, with his proclivity for challenge, chose glass because it was the "material most foreign to fiber." Setting out to control the brittle glass threads, he began testing and improvising, consulting with whatever experts on glass he could scout out. This pattern, of immersing himself in a project and coupling trial-and-error testing with a willingness to seek out and accept the expertise of others, remains as much a Chihuly hallmark as his interest in glass.

Doris Brockway, the professor who gave Chihuly that weaving assignment, compares him to the textile designer Jack Lenor Larsen, another Brockway student and native Washingtonian, who has long championed Chihuly. "Once started on a track," says Brockway, "both of them knew exactly what to do, where they needed to go next."

Chihuly was born in September of 1941 in Tacoma — a major Washington seaport and railroad depot in full sight of Mt. Ranier. His father George Chihuly was a butcher and an international organizer for the meat cutter's union; his mother, Viola, had an equal facility with people and gardening. A brother, George, six years older than Dale and greatly admired by him, completed the Chihuly family.

Within his first two years of high school, Chihuly lost both his father and his brother. His brother was killed in a Naval aviation practice flight in Florida when Chihuly was fifteen; little more than a year later, his father died of a heart attack.

Understandably, after these losses, Chihuly and his mother grew increasingly close and this relationship remains at the center of his life. At her urging, he enrolled in the University of Puget Sound in Tacoma. Within one year, however, he decided to transfer to the University of Washington in Seattle, spending the intervening summer (as he had previous summers) working at a local meat-packing factory. After a year at the University of Washington, he entirely remodeled his mother's basement, a project that gave him a first notion that interior design should be his field.

At the end of the summer, says his mother, "he just decided he was going to Europe, and that was that." Quitting his position as rush chairman for the D.K.E. fraternity and selling the Austin Healy left to him by his brother, Chihuly sailed for Europe on the SS France.

Chihuly based himself in Paris for the first few months, faithfully keeping a journal and a sketchbook, and then traveled to Israel to work for a month on a kibbutz in the Negev Desert. When he returned to the United States, it was with new resolve and direction. To this day, Chihuly considers that year "paramount," and says he came back "completely changed."

From this point on, the pace of Chihuly's life accelerated, as if he were making up for lost time. He re-entered the University of Washington as a major in interior design, studying under Hope Foote and Warren Hill. Weaving became a major focus of his efforts, and he soon introduced the element of glass into his work. Since his work in glass at this period, during 1964 and

1965, predated by several years the explosive development of the studio glass movement, Chihuly had to be particularly resourceful in order to obtain both advice and materials. Despite these difficulties, pieces such as the window weaving that hangs in his mother's home* attest to both his technical innovation and his concern, even at this early stage, with fusing such disparate elements as metal, glass and fiber into a fluid construction.

Chihuly still considered himself primarily a designer and weaver, however, and after receiving his degree in 1965, he began working as a designer for John Graham Architects in Seattle. Both his interest in glass and his desire to travel seemed to increase rather than diminish after taking a position with the firm, and he left John Graham after nine months.

Determined to further his studies in glass, Chihuly earned money for school by working as a commercial fisherman, catching salmon off the Alaskan coast. He used the proceeds of this labor to enroll in Harvey Littleton's program at the University of Wisconsin. Littleton, the "father" of American studio glass, had set up an M.F.A. program in glass at the University and it was a natural choice for Chihuly.

At Wisconsin, the flow of information from student to student was at least as important as the formal teaching. While much of that ambience was due to the experimental nature of working in glass, especially in 1966, a good part of the exchange took place with artists in other media as well. Wisconsin was probably the first place, in fact, where Chihuly experienced the life of an artist.

Completion of Wisconsin's M.F.A. program required two years, but after only one year, Chihuly decided to take an M.S. degree from the University in order to accept both a place in the M.F.A. program and a teaching assistantship for the coming year at the Rhode Island School of Design in Providence.

Providence is an industrial city on the ocean, and RISD was a dynamic art school with the potential for interdisciplinary sharing of ideas. Despite the fact that the School's glass department was still in its infancy, the prospect of building his own equipment and the opportunity to consult with experts in related industries and arts excited Chihuly.

In Providence, Chihuly set himself a specific work goal: to

*Illustrated in chronology.

introduce neon into his projects in glass. John Landon, an Alaskan lumberjack and close friend of Chihuly's, remembers those early pieces as "kind of amoebic forms, filled with neon and placed on a pedestal that housed a transformer, so that they lit up when you walked by." Injecting neon into anything other than standardized glass components presented a technical challenge, and Chihuly's second priority in Providence was to develop a network of contacts, consultants and friends.

Chihuly's knack for locating complementary personalities and talents, which in Wisconsin had led to productive artistic relationships, continued to develop in Providence into a lifestyle that merged friendship with artistic partnership and led him to espouse what may be his one ideology: collaboration.

At about this time, painter Italo Scanga, who had taught at RISD a few years earlier, returned to give a guest lecture. Chihuly was completely taken with Scanga's presence, art, and ideas, and made it his business to get acquainted, thus initiating his most enduring friendship. Scanga increased Chihuly's willingness to take the same kind of risks with artistic ideas as he had been taking with technical innovation. Later, as the blanket cylinders began to take shape, Scanga urged Chihuly to "let loose and draw" on the glass. Scanga says, however, that while he may have given Chihuly a greater sense of what it is to be an artist, "somehow, whatever it is he wants to do, he gets it done."

In late fall of 1968, Chihuly received news that he had been awarded a Fulbright grant to study glassblowing at the Venini Factory on the island of Murano in Venice. This was, in fact, his second Fulbright award, for he had received but did not make use of a grant to study weaving in Finland prior to entering Harvey Littleton's program at Wisconsin. Not long after receiving the 1968 Fulbright, he got a Tiffany Foundation grant for independent work in glass. That summer, before leaving for Venice, he taught for the first time at the Haystack School, in Deer Isle, Maine. Haystack is a summer school for artist-craftsmen organized into a series of intensive three-week workshops and Chihuly had been recommended to Francis Merritt, then Haystack's director, by Jack Lenor Larsen.

Chihuly was extremely taken with Haystack. The School offered an idyllically beautiful setting and an intimate but active

environment that fostered a vital exchange of ideas and skills. Chihuly was already beginning to envision the perfect art school for glass, and three years later, when he founded the Pilchuck School, he incorporated many of the best attributes of RISD and Haystack.

The year in Venice provided Chihuly with a respite from his previous dedication to prolific output. At the Venini Factory he spent many hours watching the workers' practiced orchestration of glass production and he won the respect and friendship of Santillana, its director. While Chihuly had much to learn from the collaborative expertise of the Venini workers, he was able in turn to offer them an introduction to the more unified approach to design and fabrication taken by most American studio glass artists.

Chihuly may have been influenced more by the ambience at Venini — including such informal habits as the constant presence of a boiling pot of water for pasta — than by the specific pieces being produced there. The only piece he actually constructed while in Venice was a prototype for a large-scale lamp design* — an object more akin to his own previous work than to the forms he'd observed at Venini.

That spring, Chihuly visited the Libenskys, in Czechoslovakia, whose workshop produced heavy cast glass which differed radically from the Venetian work he had studied during the year. From Czechoslovakia he went to Germany to visit Erwin Eisch, one of his favorite glass artists, before spending a month on the west coast of Ireland.

Once back in Providence, Chihuly assumed a full-time teaching position at RISD and began a ten-year stint as Chairman of the Glass Department. He set to work building equipment and gathering students from a wide variety of backgrounds. His main objective was to generate a high-energy program capable of attracting the best possible students. Foremost among the students that Chihuly's glass program attracted that fall was James Carpenter.

Having just completed his first year as an illustration major, with a specialty in botanical drawings, Carpenter quickly established a friendship with Chihuly, and the two began working together less as teacher and student than, to quote John Landon

*Illustrated in chronology.

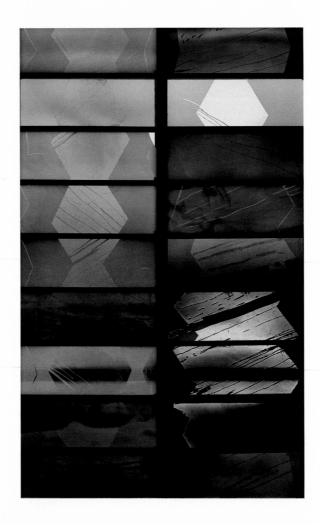

again, as "a twin-engine vehicle — they both got where they were going faster."

In the years between 1969 and 1971, Chihuly and Carpenter produced a number of large-scale environments, mostly in glass and neon, that brought both of them into the public eye and set new directions for the glass movement throughout this country and abroad. In fact, much of the work that came out of RISD's glass shop during the early Seventies tended toward large-scale site and conceptual pieces, moving away from the Sixties emphasis on smaller scale objects inspired by ceramics.

In 1971, with a $2000 grant from the Union of Independent Colleges of Art, Pilchuck became a reality when Chihuly with a crew of friends and students set up the first school solely dedicated to glass on a tree farm north of Seattle. The land had been donated by John Hauberg and by Anne Gould Hauberg, influential art patrons in Washington. Jack Lenor Larsen, a friend of the Haubergs, had introduced them to Chihuly and throughout the following years, the Haubergs continued to contribute essential funds and direction to Pilchuck.

Chihuly joined Jamie Carpenter in Venice in the spring of 1972, after Carpenter had completed a year at Venini. When the pair returned to the United States, they began a series of architectural glass projects at Pilchuck which united blown, cast, and surface-treated elements to create wall and window works. Barbara Vaessen, a Dutch flat glass artist then married to Carpenter, also contributed to this collaboration. However, the intensity of the earlier collaborative efforts was abating, for Chihuly's priorities were shifting more towards teaching, and Carpenter was spending more and more time on his own conceptual and design projects.

In the fall of 1972, Chihuly visited Mayan sites in the Yucatan and throughout Mexico. The month following the Mexican trip he spent alone on the Caribbean island of Virgin Gorda. On Virgin Gorda Chihuly made the decision to return to RISD in order to develop the glass program further. He intended to devote only the summers to Pilchuck. Although he had toyed with the idea of moving out West permanently, he feared it was too early to abandon the East Coast art world completely and he was too restless to establish himself in only one spot.

It was not until late in the summer of 1974 that Chihuly, Carpenter, Scanga, and Kate Elliott, a young glass student who had been assisting Chihuly over the past two years, began pulling thin threads from the richly colored Kugler rods they had been using to pigment glass in an effort to find a means of drawing on glass. Chihuly later that fall put the newly devised "glass pick-up technique"* to work, beginning his first important systematic series, the blanket cylinders, and initiating the work that would lead to his first critical acclaim as an independent artist.

More than ever, with the cylinders, collaboration became essential. For the early cylinders, Kate Elliott executed many of the glass patterns that Chihuly had derived from actual Navajo Indian blankets, while two or three other assistants aided in the process of blowing, then rolling the cylinder on the marver to pick up the surface color and drawing, and finally reheating it to fuse the layers. Because Chihuly was so actively engaged in teaching, his students became one of his natural sources for assistants.

In the summer of 1975, while helping to set up a glass program at the University of Utah's Snowbird Art School, Chihuly met glass artist Flora Mace, who became an important collaborator. Mace came to RISD and developed the blanket drawings to their highest technical level. Chihuly spent most of that summer with Seaver Leslie, another RISD collaborator, organizing the first major museum shows of the cylinders—at the Utah Museum of Fine Arts, Salt Lake City and the Institute of American Indian Art, Santa Fe. Chihuly and Leslie also worked at Pilchuck, and then collaborated on a project at Artpark, Lewiston, New York, in August.

Later that fall, Mace and Leslie worked with Chihuly on two series of cylinders, a "Ulysses" series drawing upon images from Joyce's novel and an "Irish" series based on Irish folklore. With the intention to lecture on these "literary" cylinders at several English and Irish universities, late in the fall of 1975 Leslie and Chihuly took off on a tour through England and Ireland. Before they reached Ireland, while still en route to British painter Peter Blake's country home, they had a devastating automobile accident that left Chihuly both badly scarred and minus the sight of one eye.

*Illustrated in chronology.

Recuperating first in England and then at his home in Providence, Chihuly blew no glass for several months. He did, however, organize an important one-man show of the cylinders, at Brown University's Bell Gallery, where he juxtaposed the cylinders with Navajo blankets that had provided the inspiration for the drawings on their surface. He also agreed to head the Sculpture Department at RISD for a year.

If prior to the accident Chihuly's commitment to collaboration had served to create a dynamic and effective working method, now it became a necessity. Maneuvering the blowpipe requires accurate depth perception, and while Chihuly had sufficient experience to manage intuitively much of what he could no longer actually perceive, there is no denying the extent of his dependence on others for at least some of the operations. In many ways, the accident propelled Chihuly into a new kind of collaboration. Paul Hollister, a New York painter and writer specializing in glass, observed, "What Chihuly couldn't see [after the accident] because of his eye problem, he couldn't see before, because he was too close to the piece."

Devising a means to work around his injury and relying on a new objectivity about the glassblowing process, Chihuly initiated a shift in his working methods to develop a form of collaboration quite different from the earlier tandem work with Carpenter or Seaver Leslie. Greater financial independence from the sale of his work now allowed him to hire and pay assistants for particular blowing sessions. And, as he distanced himself somewhat from the physical aspects of forming the glass, he gave new emphasis to the creative phases preceding and following the blowing, that is, to drawing and photography.

With the preliminary drawings, the mark of Chihuly's hand is more directly present than in the glass itself. Chihuly's lines on paper, often worked with a handful of pencils at a time, reveal a probing for forms that precedes their achievement in glass. Sometimes the graphite actually rips through the paper, exposing an aggressive kind of energy often lost in translation to the smooth shiny surface of glass.

The drawings are never merely designs. Instead, they offer gestural maps for working moves, acting both as a vent for spontaneous expression and a surprisingly specific series of working

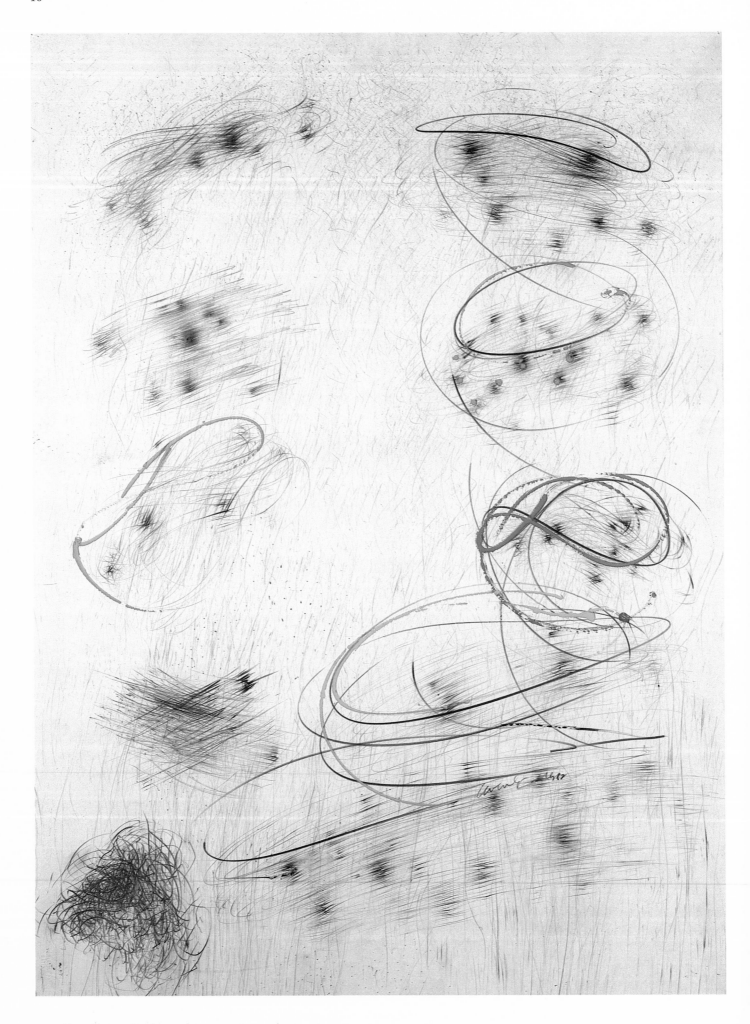

drawings. Billy Morris—a master glassblower currently working with Chihuly and capable of sensing intuitively what Chihuly wants to accomplish through the drawings—actually checks off drawings that correspond to pieces he's blown, yet Chihuly still manages to avoid rigidly predetermining the forms before they are begun in glass.

Photographing the finished pieces, by contrast, provides an analogue to the raw energy of both the drawing and the actual work in hot glass. Instead of serving merely—or primarily—as a document, the photographs take on a new equivalence with the glass. Chihuly has said the photography "dematerializes the object so that I feel I'm looking at its real spirit, its other dimension."

Chihuly's ability to distance himself from the blowing process and the visual lessons he learned from photographs of his glass helped to catapult his work into a new phase, leading to a more complex exploration of his medium. Thus, in the summer of 1977, when he spotted the Indian baskets on the shelves of the Tacoma Historical Society, he was ready to abandon his cylinder series for one more organic and responsive to the gravitational pull on hot glass.

Almost three years ago, Rose Slivka, then editor of *Craft Horizons,* contrasted Chihuly's "opaque and heavy cylinders" with his new "crumpled, wrinkled baskets," calling the baskets his "most glasslike work" to date.[1] This observation rang truer with each evolution of the basket series, until, in the sea forms exhibited last year at the Tacoma Art Museum, the Charles Cowles Gallery in New York and the Clarke-Benton Gallery in Santa Fe, Chihuly had come so close to the essence of "pure" glass that the Venetian glass produced at Venini which had inspired much of his recent work looked almost heavy by comparison.

More importantly, while the Venetian glassblowers accept elegance as an end in itself, Chihuly feels uncomfortable when his forms become too exquisite. Referring to the sea forms, he says: "This series has reached a point of elegance that I may not be able to take any further, so I'm introducing more complexity and a grotesque quality. The contrast will make you look for beauty. One of the really good *macchia* pieces [an expressive Italian term

1 Slivka, Rose, "A Touch of Glass," Gallery/79, *Quest,* September, 1979, p. 84.

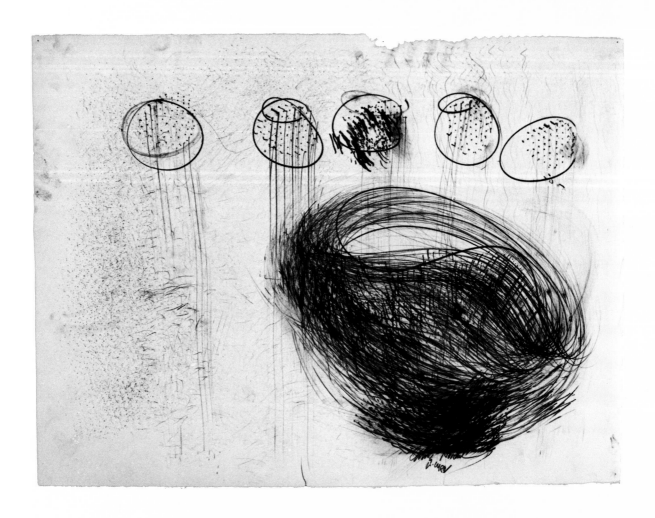

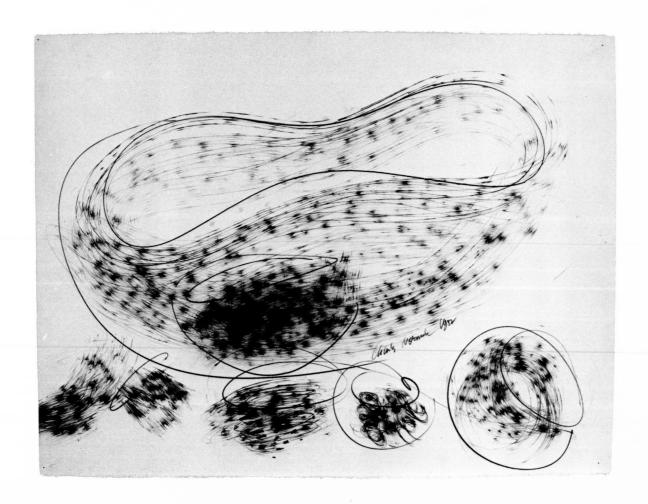

meaning spotted, mottled, or sketched-in] makes you want to look inside it."

Chihuly has said that his early interest in neon stemmed from a desire to animate the glass, to move from solid, sculptural statements to more energized environments that invited human participation and response. Given his technical developments in blowing the glass, he can now achieve the same effect without the insertion of a foreign substance.

For instance, many of Chihuly's forms take on anthropomorphic associations he finds natural to the glassblowing process. Pointing to the fact that, while his sea forms do have openings, they are not traditional containers, he says: "One thing I like about the association with sea creatures is the importance that gives to an opening or orifice. The process of blowing wants to leave a hole to account for the original entry, where the air first came in."

By evoking living forms, Chihuly's move from graceful to more awkward objects becomes plausible in a way that could never be if his only motive were to fashion ever purer vessels. For Chihuly is no formalist; he needs to imply movement and growth. His technical innovations and refinements serve only to provide more options — relating to what he can make glass do and what associations he can suggest to natural phenomena.

Most of the pieces since mid-1980 have been blown into an optical mold, giving the tough soda-lima glass Chihuly employs a ridged surface that can be stretched extremely thin. When glass threads are trailed over the ridges in a continuous motion, they adapt to the specific contours of each vessel, so that, as in the Indian baskets that inspired them, form and surface decoration occur simultaneously. This is in marked contrast to the applied blanket weavings on the earlier cylinders. Evolved as a means toward approximating that fusion of surface and support in the Indian baskets, Chihuly's innovative adaptations of essentially Venetian methods unleashed a range of new possibilities that had little to do with attempting a more direct approximation of basket forms. While the blanket cylinders limited variations on the original theme to color and drawing, the Indian basket series offered a far greater potential for formal exploration.

As already noted, Chihuly is strongly driven by a visual sensibility. It was necessary for him to see the woven, warping baskets

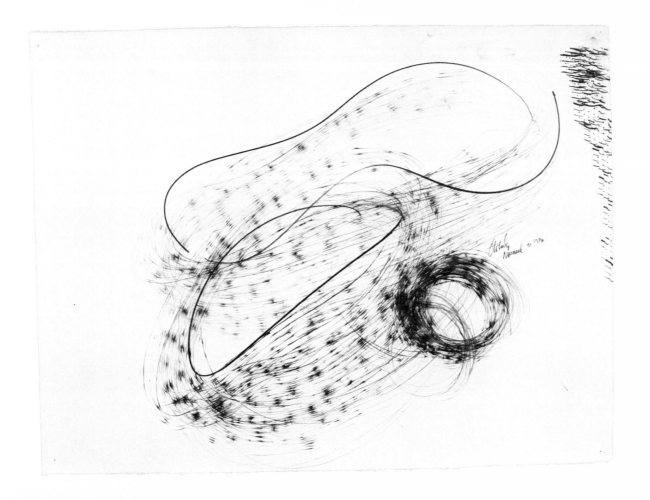

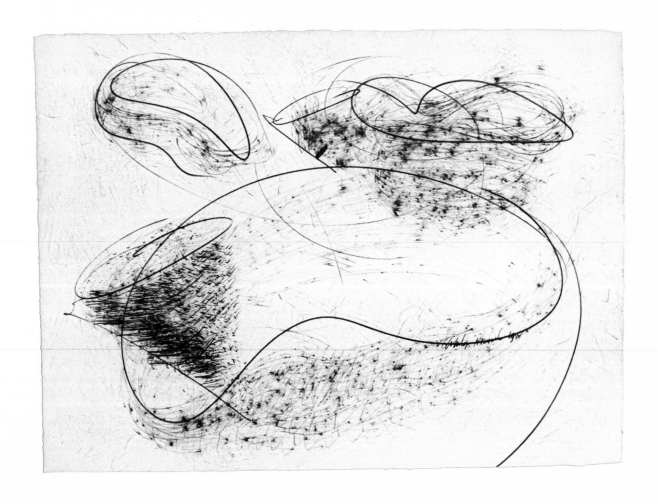

on the Tacoma Historical Society's shelf in order to visualize similar effects, transformed by the glass. And Carpenter has said that when he and Chihuly first began pulling glass threads at Pilchuck, Chihuly immediately made a visual connection between the threads and woven fibers, linking his experience of weaving to options for form-ideas in glass.

Chihuly has a profound interest in objects whose functional and aesthetic identities cannot be separated. This is not to imply that Chihuly has ever really made, or wanted to make, functional wares. His interest is more akin to the type of aesthetic concern expressed in the work of German artist Erwin Eisch, whose glass forms depicted, in Chihuly's words, "simple functional forms that he made non-functional," such as a beer stein filled with permanent foam, or a flower pot with a little cactus, "so you couldn't put anything into it." But Chihuly takes the overt references in Eisch's work one step further toward abstraction and gesture.

Chihuly devises a technical means to replicate not a visual source itself, but its gestural equivalent in glass. As his control over the glass grows, the original form becomes more poetically abstract and implied. The blankets retained their blanketness, and the Pilchuck baskets were, at first, simply glass imitations of the Indian prototypes, submitting to gravity more rapidly, perhaps, but maintaining direct reference to their source. With the sea and shell forms, however, Chihuly is moving increasingly away from the specific toward the abstract. While he obviously had in mind such characteristically Venetian concerns as lightness, freedom of shape, and infatuation with color, Chihuly's recent forms emerge from the depths of an independent, vital imagination. He did not set out to base a series on sea creatures; the name came up because the association was inescapable. Mesmerized by the perpetual, liquid movement of real underwater flora and fauna, Chihuly recalls their slow, somnambulant motion in his gelatinous, tinted forms. The purity achieved in these works by late 1980 and early 1981 could easily have represented the apex of a lifelong artistic endeavor—the creation of glass forms so thinly spun and subtly colored that, as we move around them, they flicker and vanish, becoming evidence more of light than of matter. By darkening the glass, so to speak, as he did in the

macchia pieces immediately following the sea forms, Chihuly reveals his willingness to dive back under the beauty and into his imagination.

Scanga has likened the *macchia* pieces to some of Jackson Pollock's paintings of the late Forties. As always with Chihuly, any connection should not be discussed as intentional. In writing about Pollock, Bryan Robertson pointed out that Pollock's "search for images of the widest possible reference and implication exactly coincided with his parallel search for an abstract statement of the utmost potency and tension...an abstraction informed and regulated by the banished imagery...derived from the earlier presence of the imagery and its movement in space."[2] The statement could apply equally to Chihuly's current transformations of "subject matter."

Jamie Carpenter, who is as conceptual an artist as Chihuly is intuitive, has said quite simply of Chihuly: "Dale's real forte is in sensing the value of an idea and executing it in all its permutations. He has a very good interior sense of things, so that, intuitively, in setting up an idea for a form, he develops an idea for its space as well.... He has a sense of the way color changes an environment."

In discussing Chihuly's current work, Carpenter speaks of the "ultimate understanding and continued respect for the vessel.... Dale sees the vessel not as a container, but as an incredible sort of environment." Like American Indian baskets, especially those made before their creators had any contact with white men, Chihuly's vessels exhibit "the patterning and surface treatment that embodies concept, as opposed to decoration—that is, objects produced as emblematic totems in which form and use become indistinguishable...."

Chihuly, of course, never spells out these relationships. So in looking at his work, especially as it becomes more abstract, one either projects personal associations—as Larsen had done in reading film-like translucent drapery folds into the ripples—or searches within Chihuly's own expressed interests for buried sources, whose ultimate role is to locate the solution of a formal concern in some real experience.

2 Robertson, Bryan, *Jackson Pollock*, London, 1960, as quoted in Busignani, Alberto, *Pollock*, Hamlyn Publishing Group, London, 1970.

In his most recent work, Chihuly's primary concern is again with movement, but the visual expression of this movement seems as much architectural as organic. In their glaring brilliance, these pieces suggest the boldest achievements in the *millefiori* tradition, but it is a fleeting reference and not a derivation. Laying color on and within transparent glass almost sticky wet in appearance, in formations resembling the rippling striations of some spidery seaweed or loose skeins of uncarded fiber, Chihuly creates "windows" into pieces where he had earlier placed surface patterning. The colors remain intensely saturated, but are transparent as well. Especially in the white-speckled pieces, much like exotic eggs, the achievement of a pigment both opaque and translucent is remarkable and Chihuly is able to render his forms at once impenetrable and accessible. There is a sense in these works of the excitement and magic of a discovery that is as yet to be fully grasped by its creator.

Perhaps it is the unexplained magic of his work that brings to mind the words of the Surrealists in trying to describe Chihuly's art. But it is the Surrealism of Picasso which best encompasses Chihuly, for Picasso, "... by the recklessness with which he views art and by the lyric frenzy in which he works, exemplifies the surrealist precept that art is not so much the production of an object ... as the expression of an attitude."[3] As Charles Cowles, Chihuly's New York dealer, has pointed out, it is in this reliance on work as the arena for discovery that Chihuly resembles Picasso. Chihuly's unequivocal commitment to work, his chronic need to set up "sessions" and to stay in motion, underscores Cowles' observation. He is rare among his peers in doing so much of his experimentation and analysis in the material, and not the conceptual realm. "The way I begin to work has to do with setting up circumstances — the right atmosphere, the right attitudes, the right people — so that something exciting can happen and you'll be ready for it. I have to be prolific, because it is continual output that allows work to develop or change." Chihuly draws on the inherent power of glass to condition light so as to envelop the forms and the space they enclose with an

3 Fowlie, Wallace, *Age of Surrealism*, Indiana University Press, p. 161. Breton passage from introduction to *Nadja* also partially quoted in Fowlie, but I have used the English translation of *Nadja*, published by Grove Press, Inc., 1960.

atmosphere that transforms the object from static representation into an evocative intimation of some phenomenon sensed in nature or daily life. The "blankets" on the cylinders *wrap* around the glass, the Pilchuck baskets succumb to the same gravitational forces as their time-warped Indian prototypes, the sea forms alternately ripple, reflect, and absorb the surrounding air, as jellyfish swimming in water appear to dissolve into their liquid surround. Chihuly manages to create entirely different atmospheric qualities as the pieces themselves change in color, form, and illusionistic association.

Chihuly plays upon forms, throws out possibilities, until he lands on some shape, some effect, some moment in the forming that feels right. Since glass lends itself to this sort of "stop-action" or "freezing," that moment translates into an object physically stopped, but possessed of the illusion of movement that was its genesis.

Later, when Chihuly assembles groupings or "families" of pieces, he recalls the seemingly random, unpredictable groupings of islands in an archipelago or ancient standing stones like those forming the Ring of Brodgar on the Orkney Isles, one of the haunting monuments which overwhelmed Chihuly when he first saw them. In these groupings, the precise location of individual elements derives, not from aesthetic design, but from geological or spiritual forces that endow the whole with a meaning, unspecific yet powerfully sensed. Chihuly's assemblages seem to suggest the same internal necessity.

In his long-standing emphasis on the documentation of both process and piece, Chihuly participates in a contemporary concern — one that he shares with artists as opposed in intention as Robert Smithson, whose site/non-site analogues often incorporated photo, and later film documentation, and Christo, who incorporates both pre- and post-event drawings and documentary films in his artistic endeavors.

Chihuly also has a willingness to embrace the social and economic realities surrounding the production and dissemination of his art that counters the stereotypical view of the artist in opposition to the outside world. He is genuinely pleased when people like his work. Yet Chihuly's personal integrity is never in doubt and above all, there is the integrity of the work itself.

Chihuly never makes work for a specific audience or function, but once produced, he wants it out, seen, in the hands of others. Like Houdini, a favorite of his, Chihuly loves a show.

The photographs of Chihuly's glass not only promote his work, but he also uses his "chromes," as he calls them, in a more personal way, as a sort of memory. As Fran Merritt described to Chihuly in a letter, "Where it would be almost impossible to reproduce the kind of forms you create, or the conditions in space you arrange for them, the photo record can theoretically be replicated forever and ever, extending the original energy and idea to eternal life."[4] It does indeed seem that Chihuly, who has never rooted himself to any one place, uses his photos as a portable history, extending the time-space of his work for himself, as well as for others.

The potential for transformation without loss of sensory impact is one of the marvelous properties of glass. And Chihuly is a master of transformation, but never of distortion. Even the new *macchia* works, no matter how distended in form or garish in color, always manage to be beautiful—and not simply because, as Rose Slivka put it, "Beauty is the nature of the (glass) beast." Yet Chihuly's vessels—by always maintaining the biological and architectural association inherent to vessels—are never "merely" beautiful.

Van Gogh observed of Japanese artists that "they live in nature as though they themselves were flowers."[5] Chihuly is likewise of nature, blowing forms that "suffer a sea-change into something rich and strange," as Jackson Pollock said of the foreign objects he placed in a painting on glass.[6]

Or perhaps, Chihuly is like the lucky mollusk, and his glass like its shell, once idealized by the French poet Paul Valéry as "...justifying its absolute value by the beauty and solidity of its form, while remaining unconcerned with the simple matter of protecting its substance."[7]

4 Merritt, Fran, Letter to Chihuly written in September, 1981.
5 Van Gogh, Vincent, *The Letters of Vincent Van Gogh to His Brother: The Complete Letters*, Vol. 3, p. 55, #542.
6 Johnson, Ellen, *Modern Art and the Object*, Harper & Row, 1976, p. 116.
7 Valery, Paul, as quoted in Gaston Bachelard, *The Poetics of Space*, Beacon Press, 1969 edition, p. 106.

27 — 1975

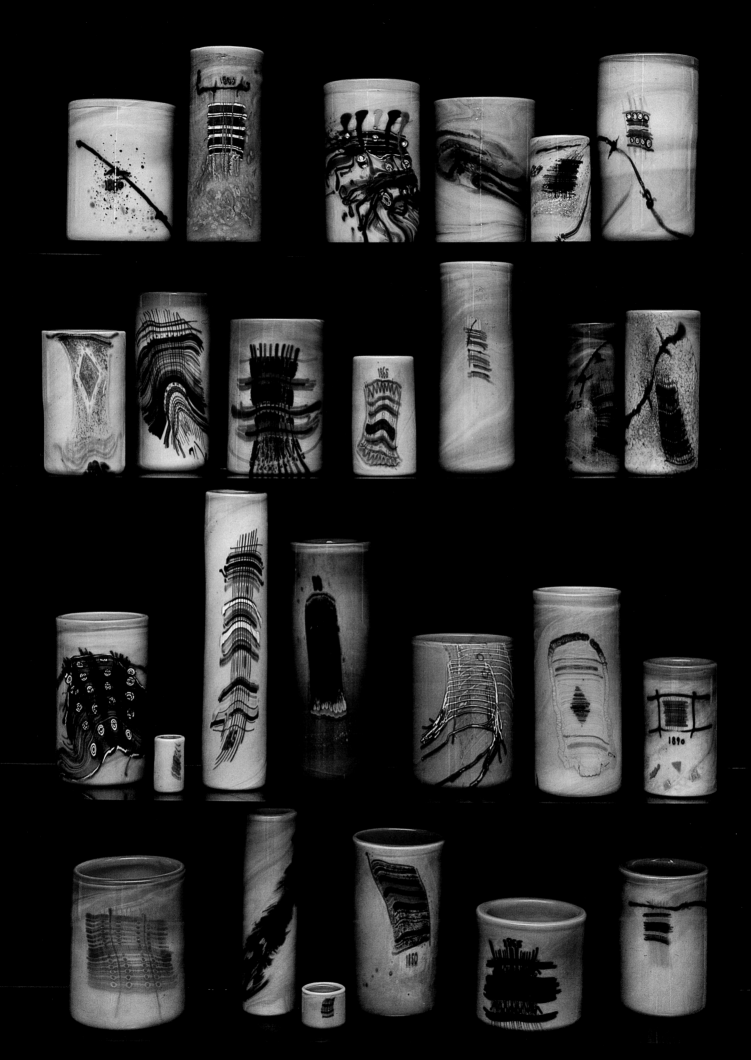

28

29 — 1976

32 — 1980

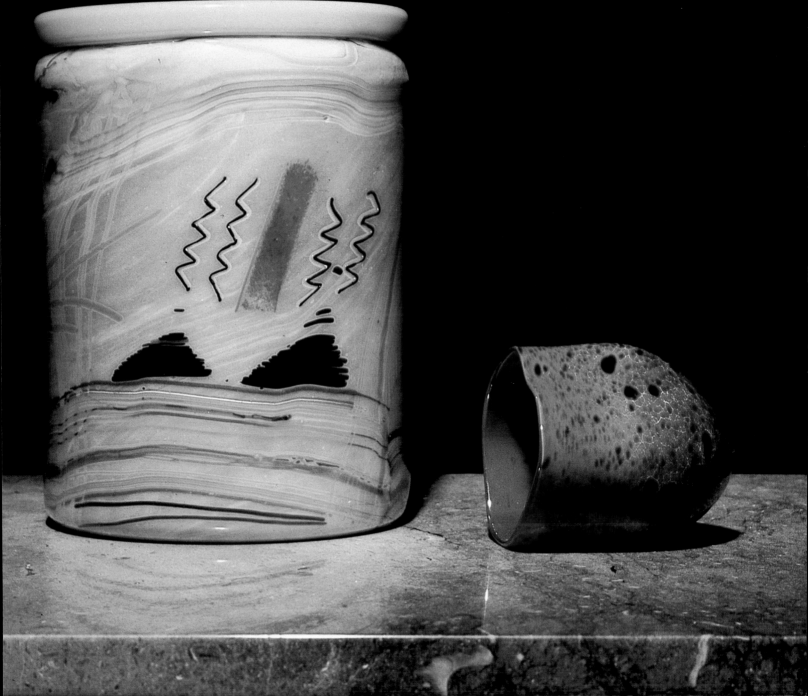

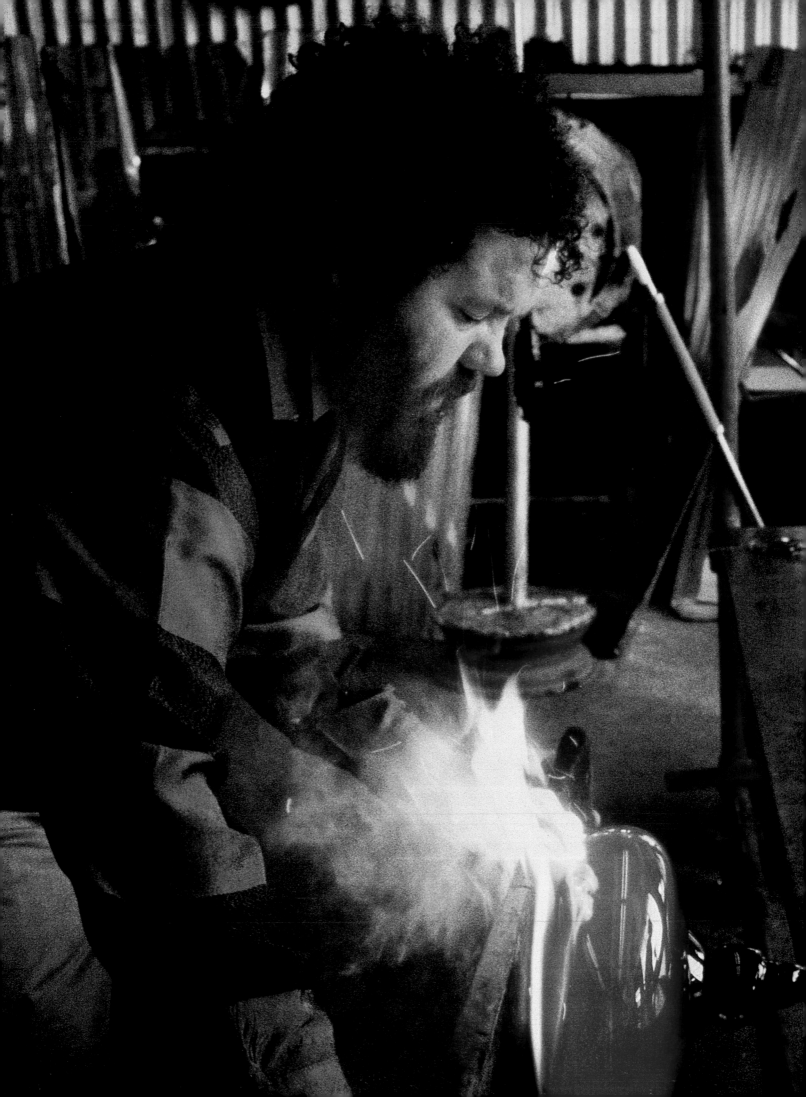

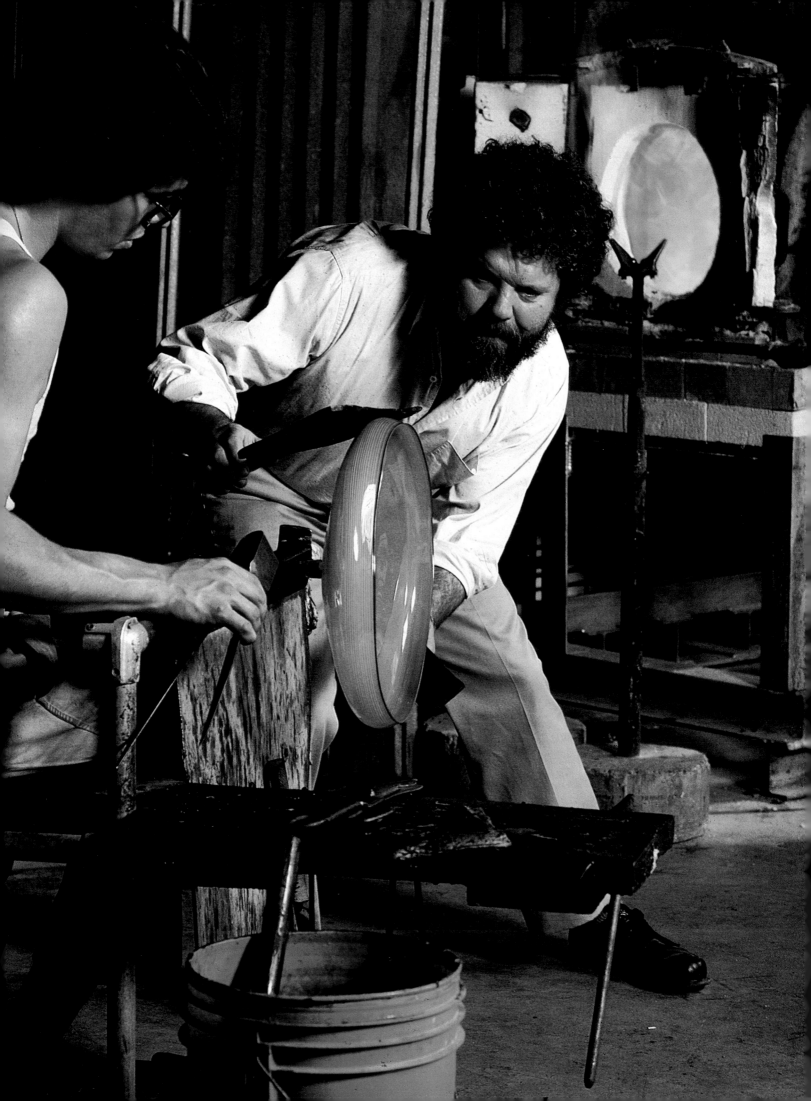

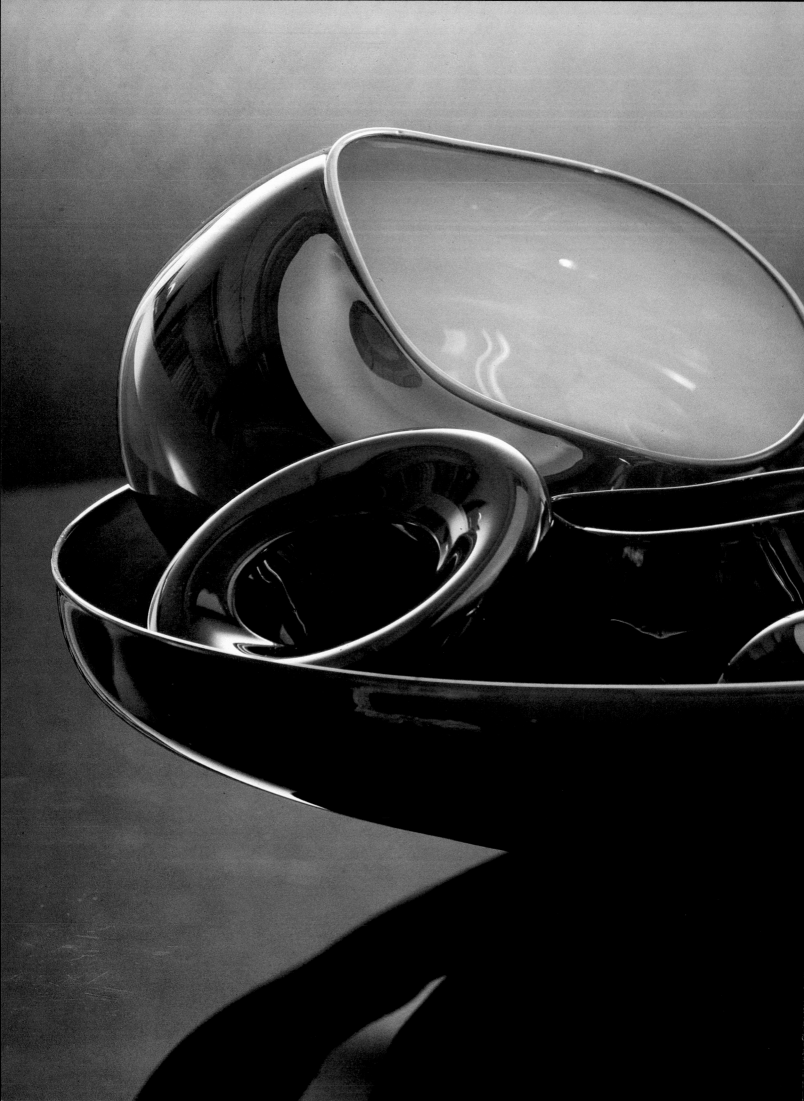

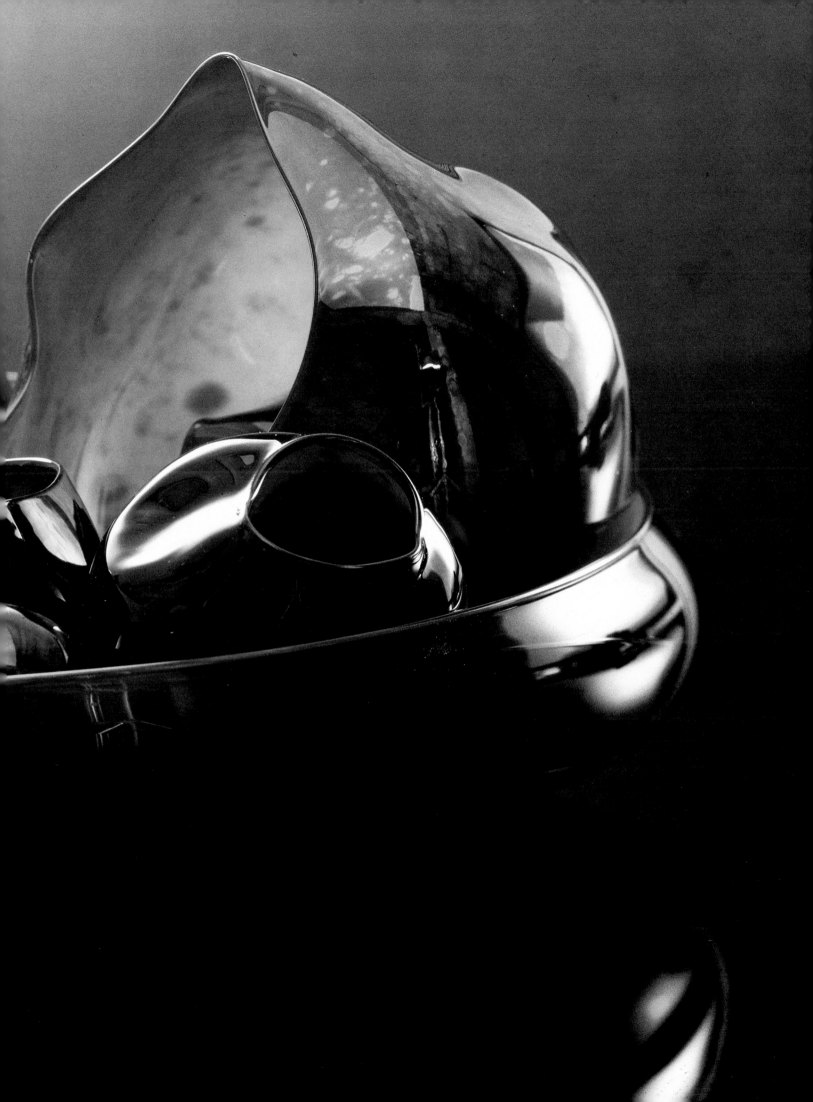

35 — 1980

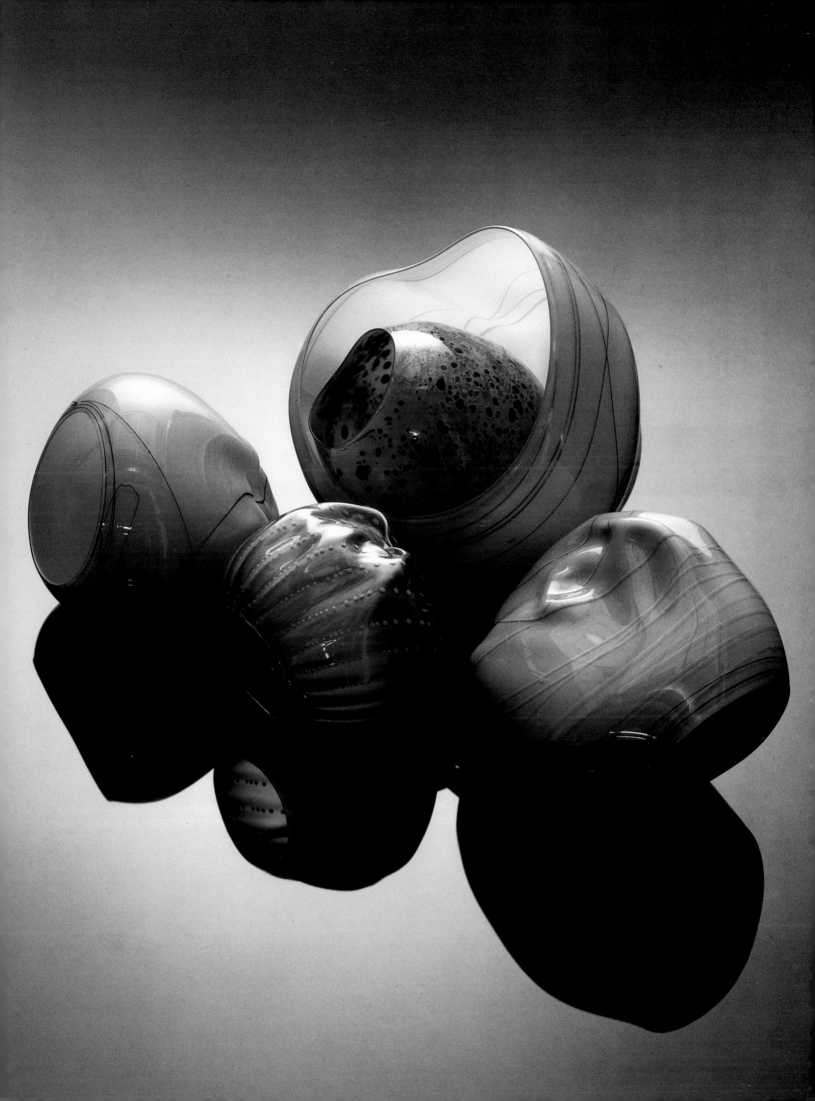

37 — 1980

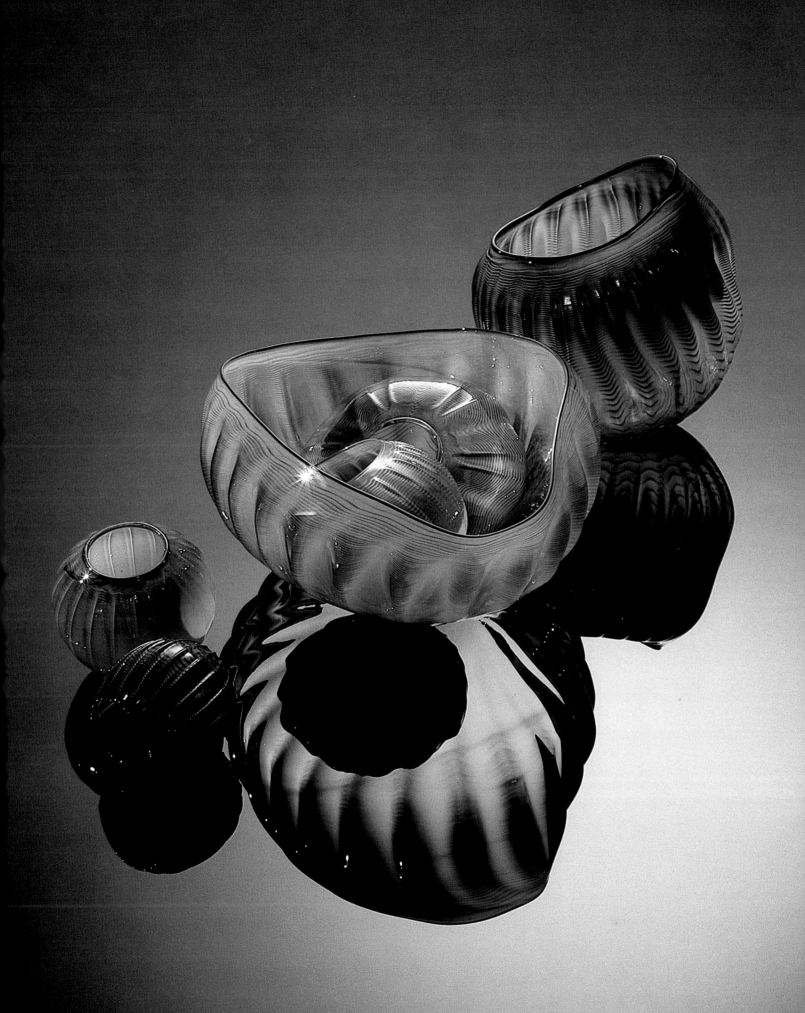

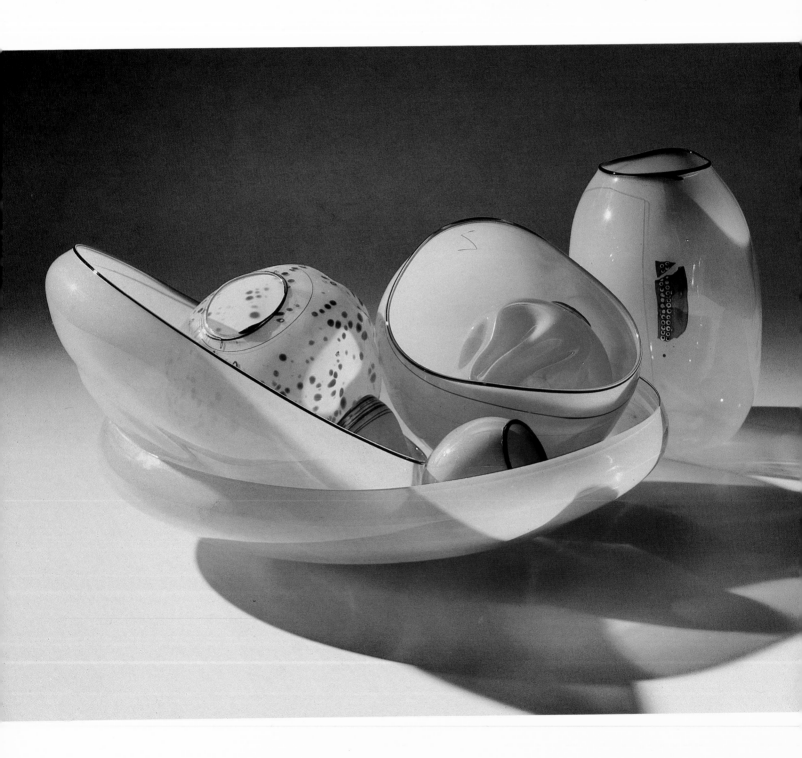

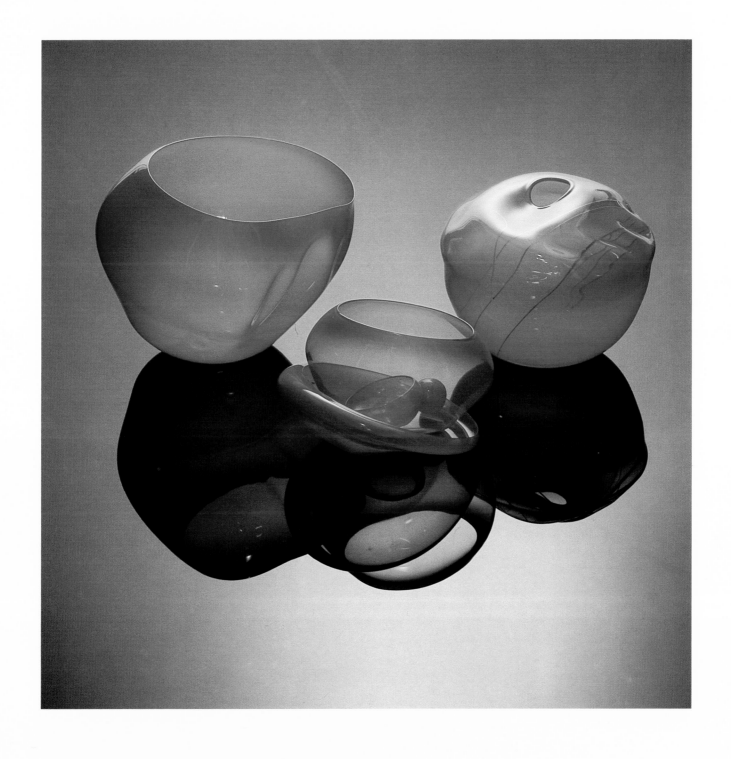

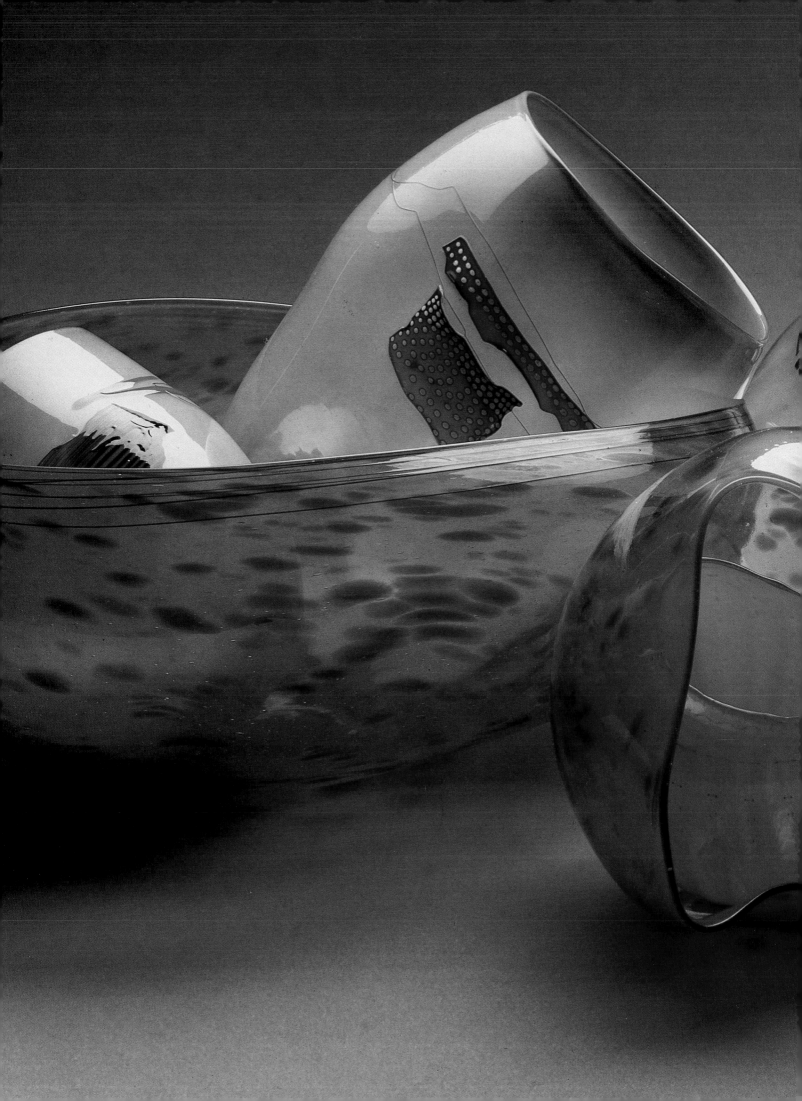

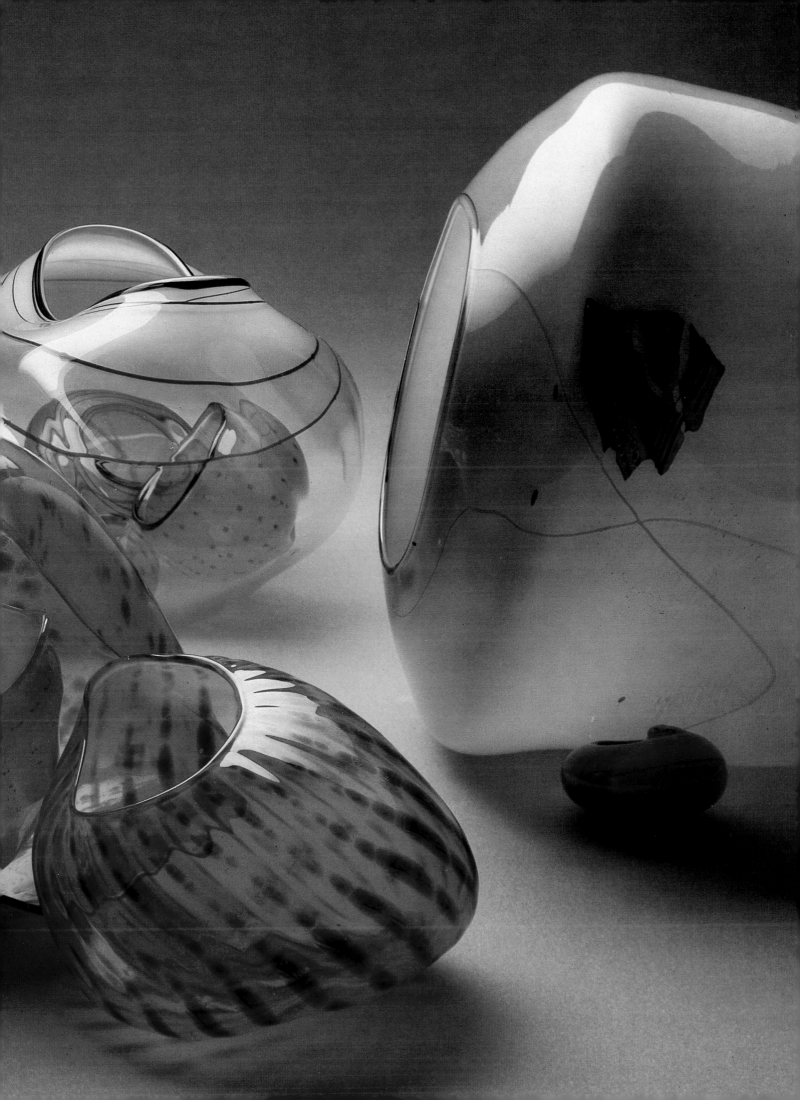

42

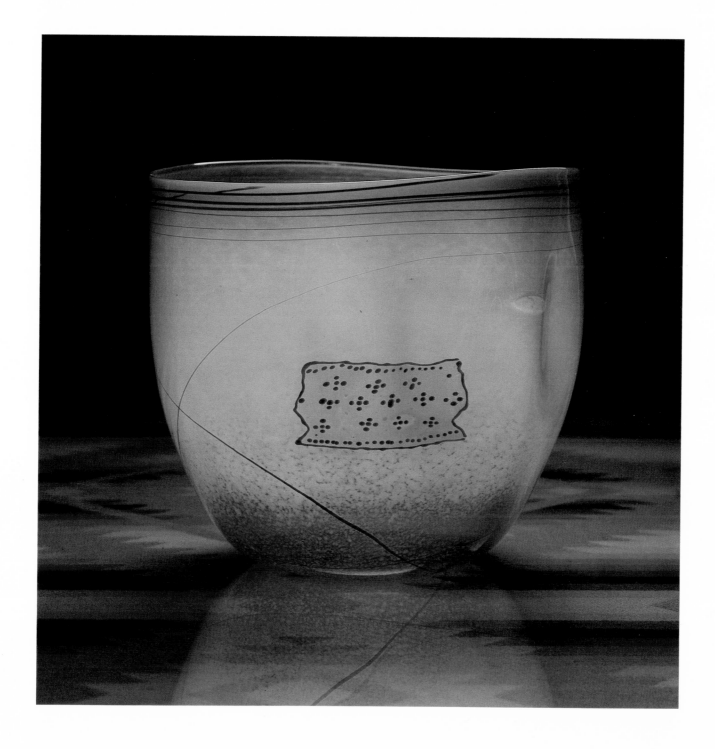

44

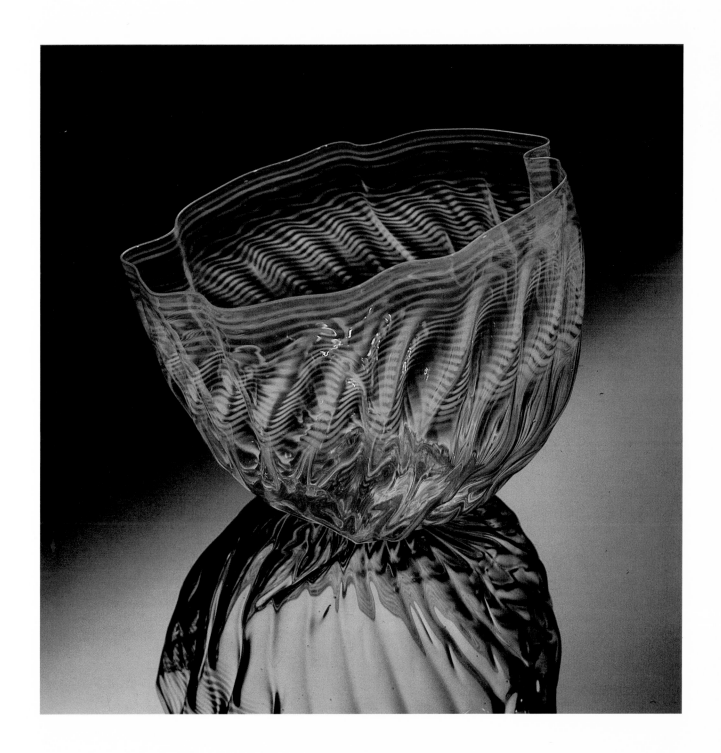

46

47 — 1981

48 — 1981

50 — 1981

51 — 1981

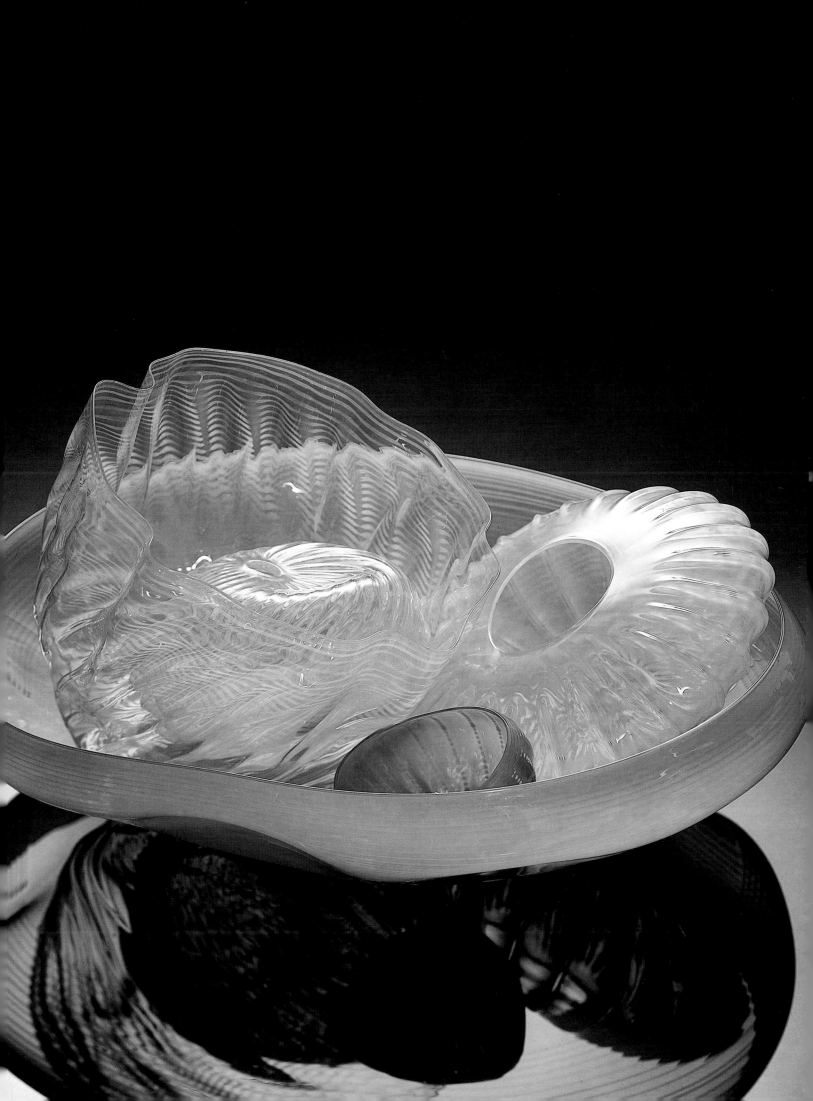

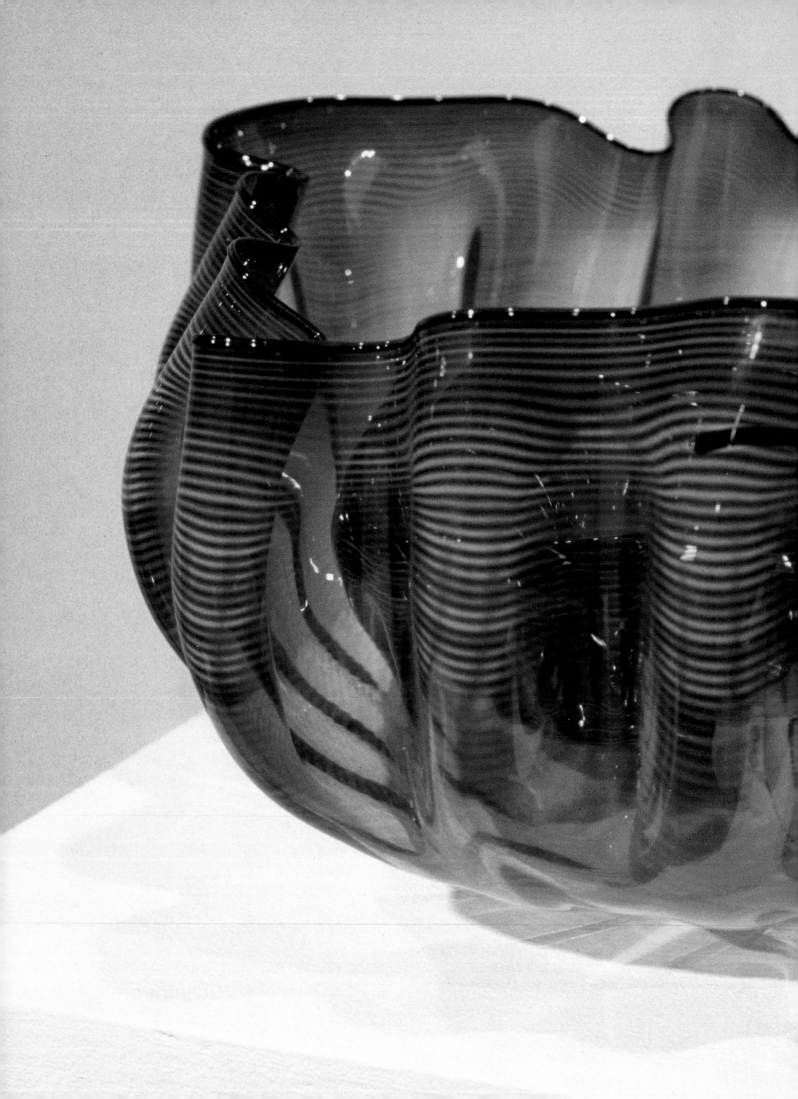

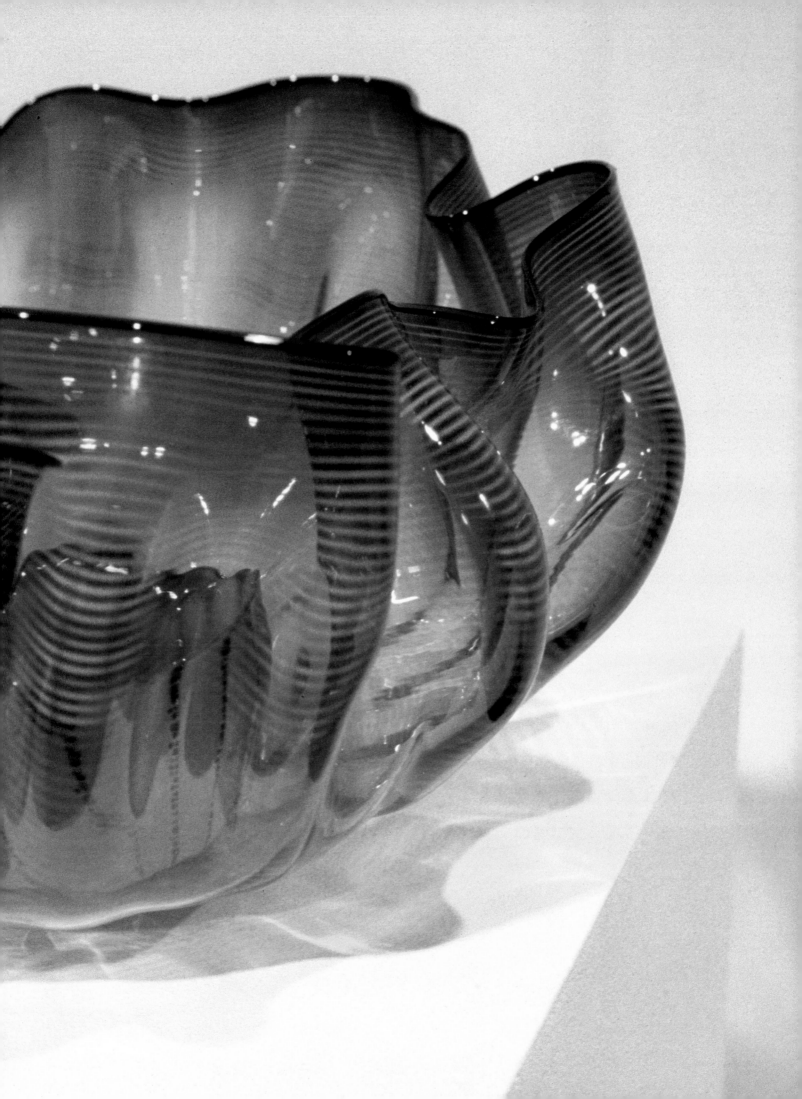

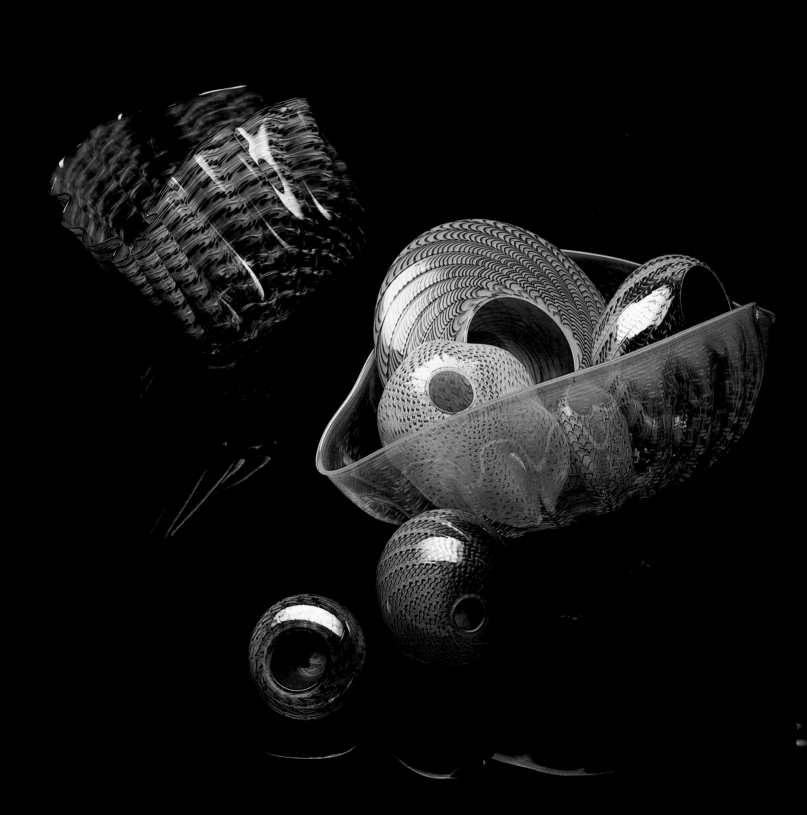

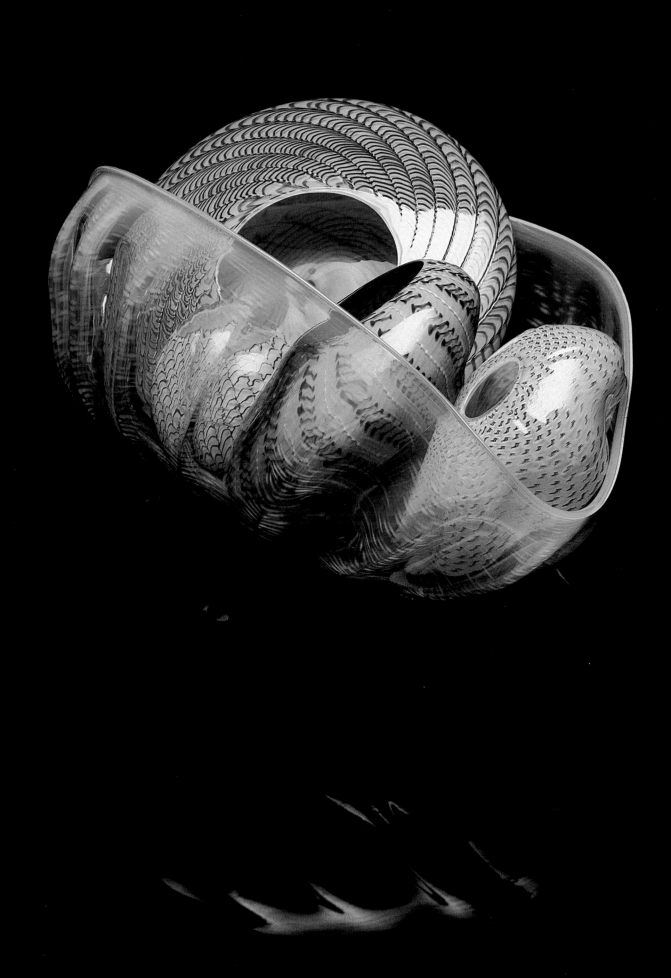

53 — 1981

54 — 1982

55 — 1982

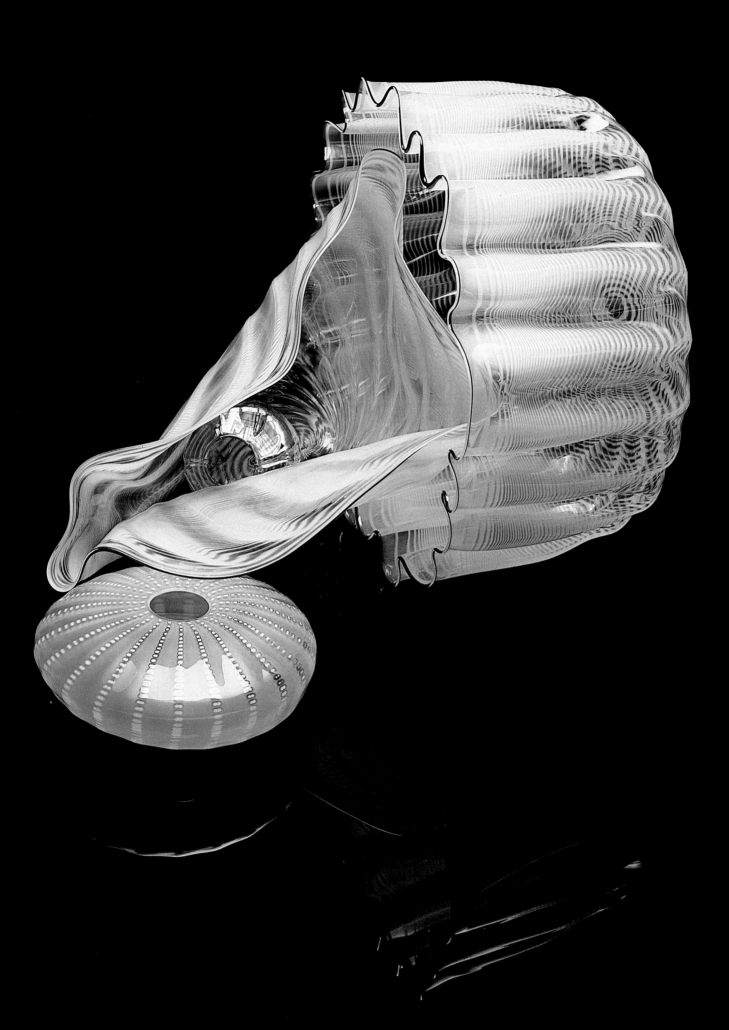

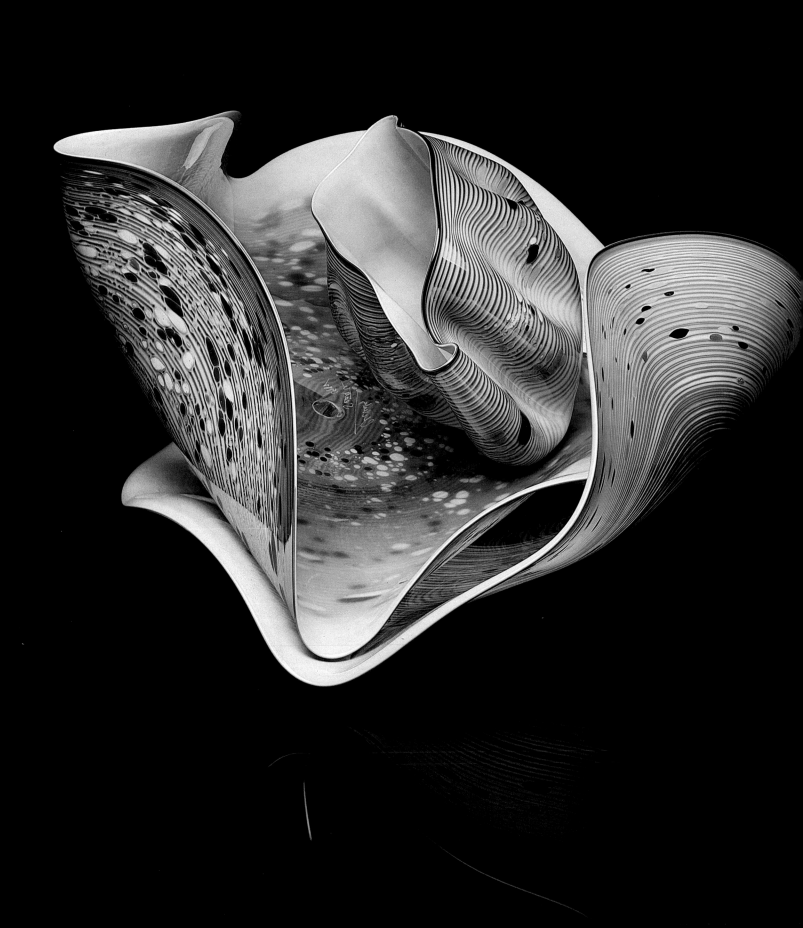

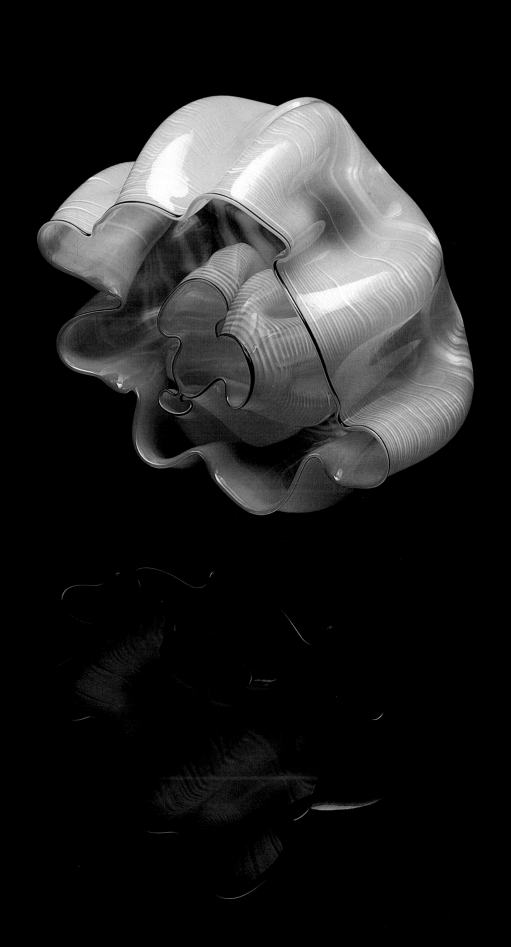

57 — 1981

58 — 1981

57 — 1981

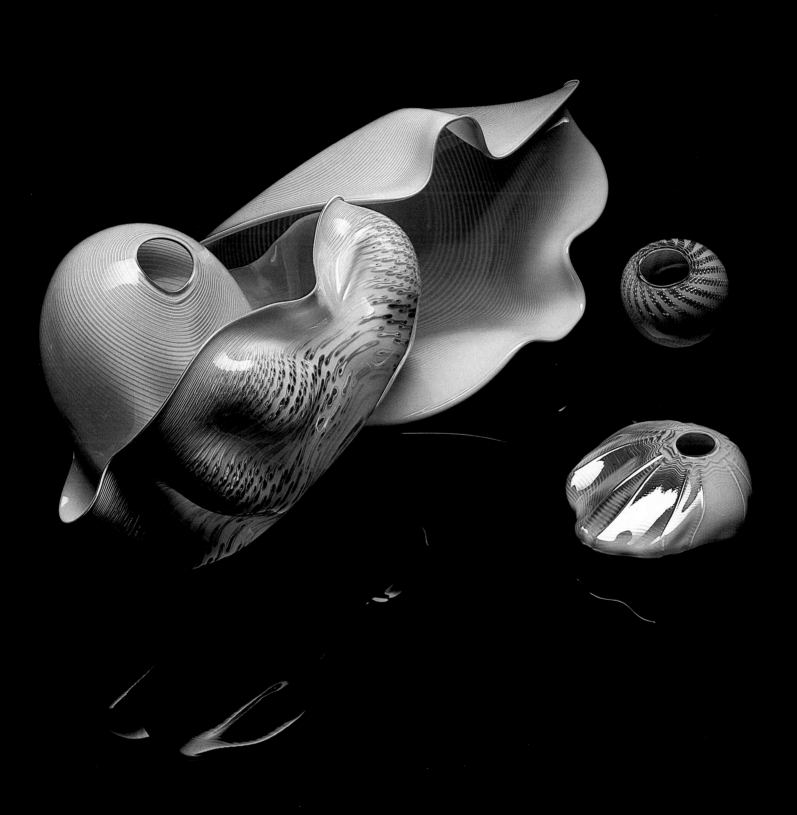

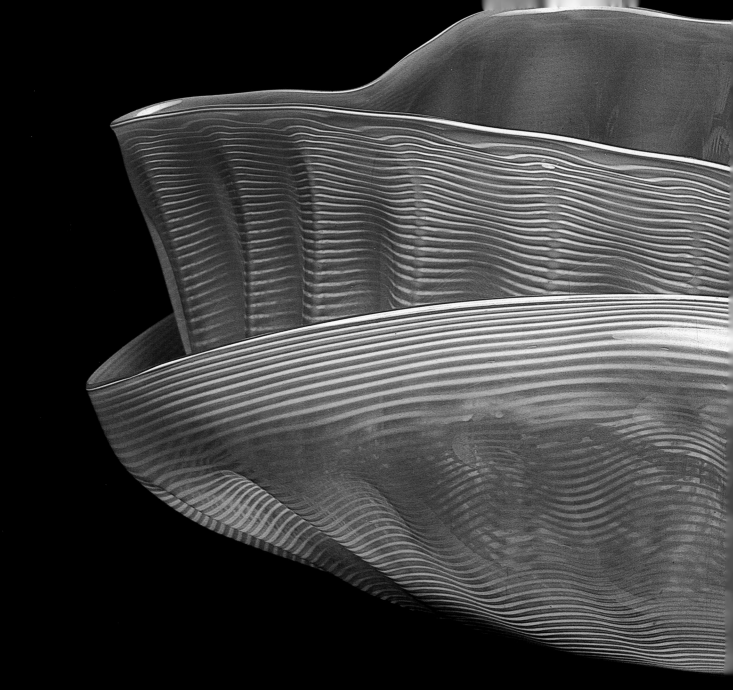

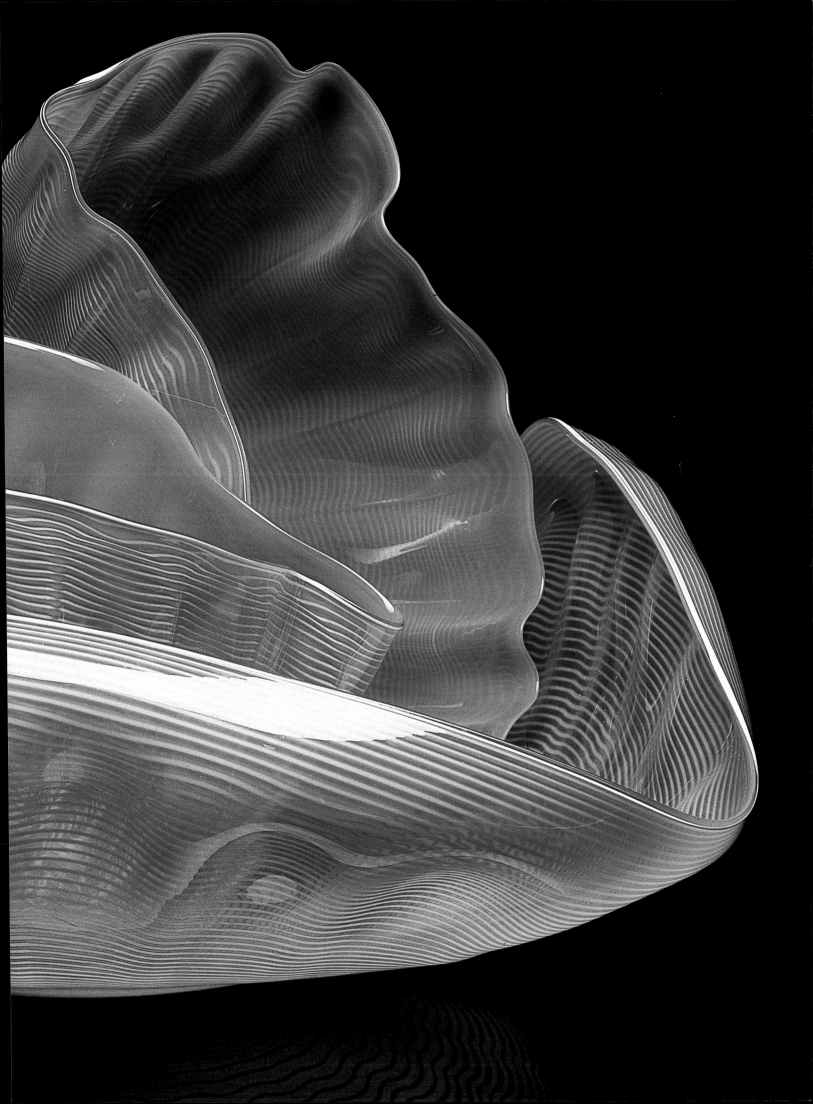

61 — 1981

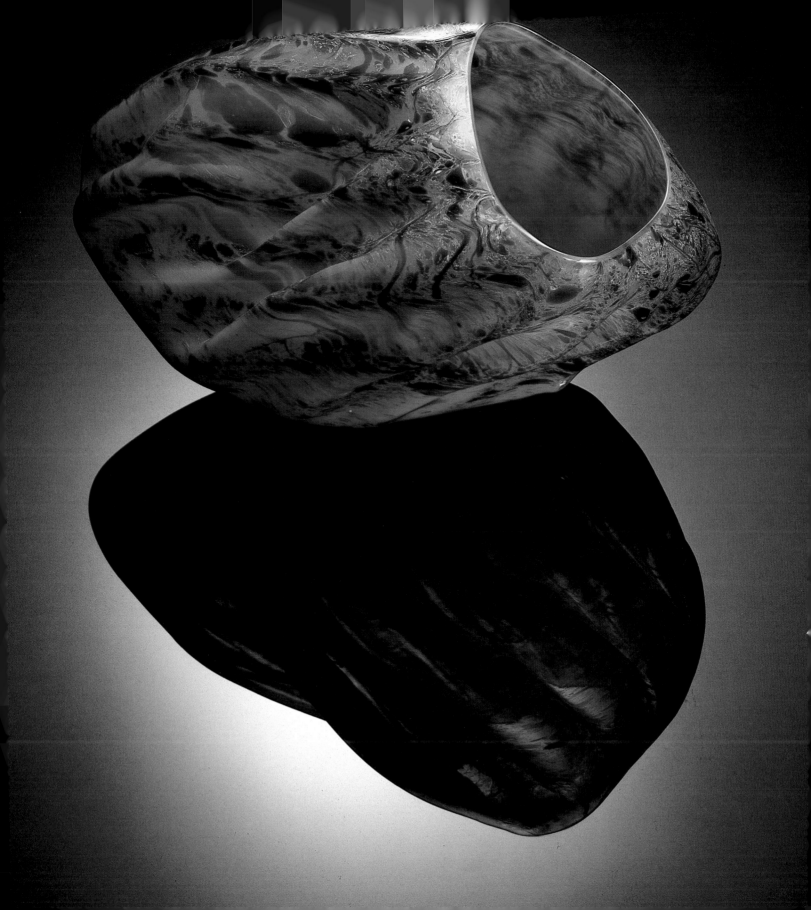

63 — 1981

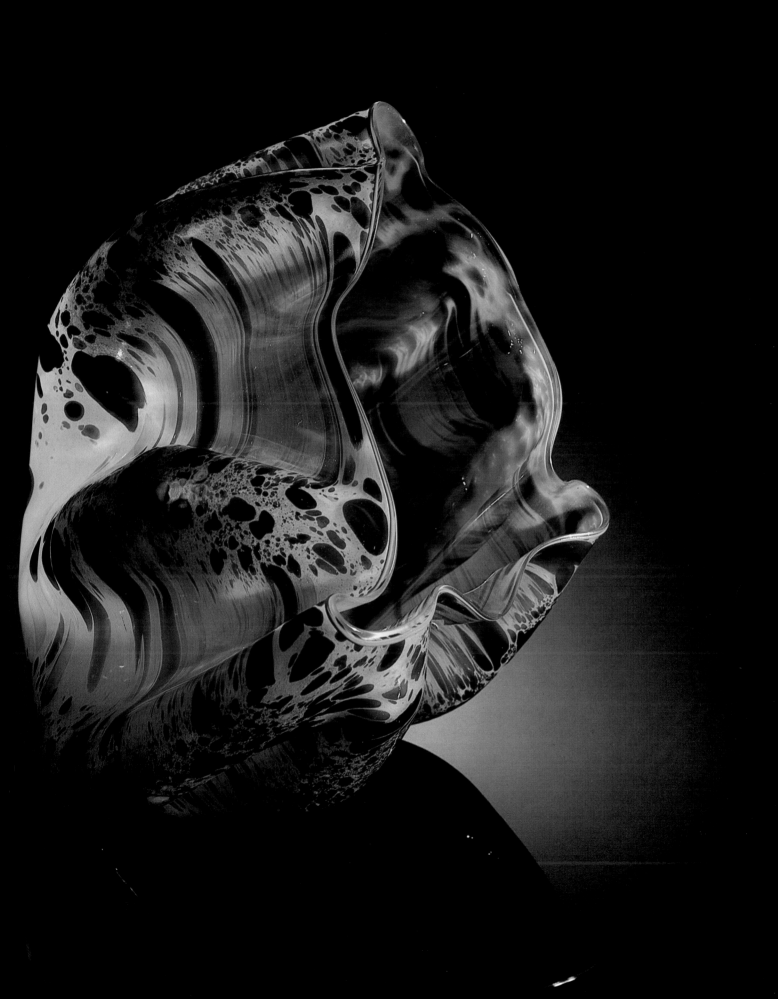

65 — 1981

66 — 1981

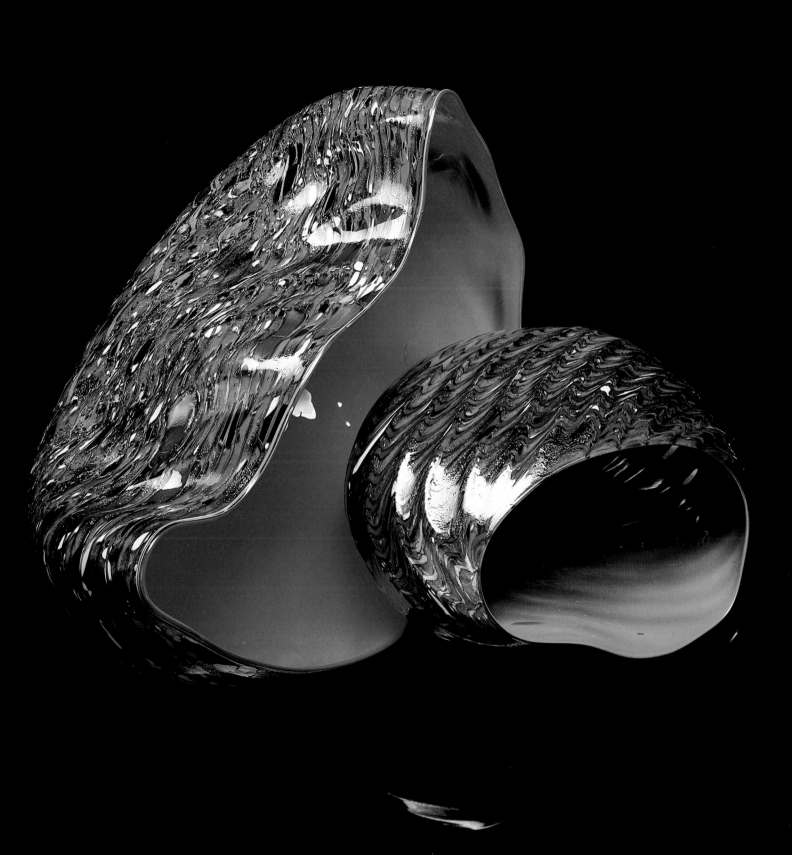

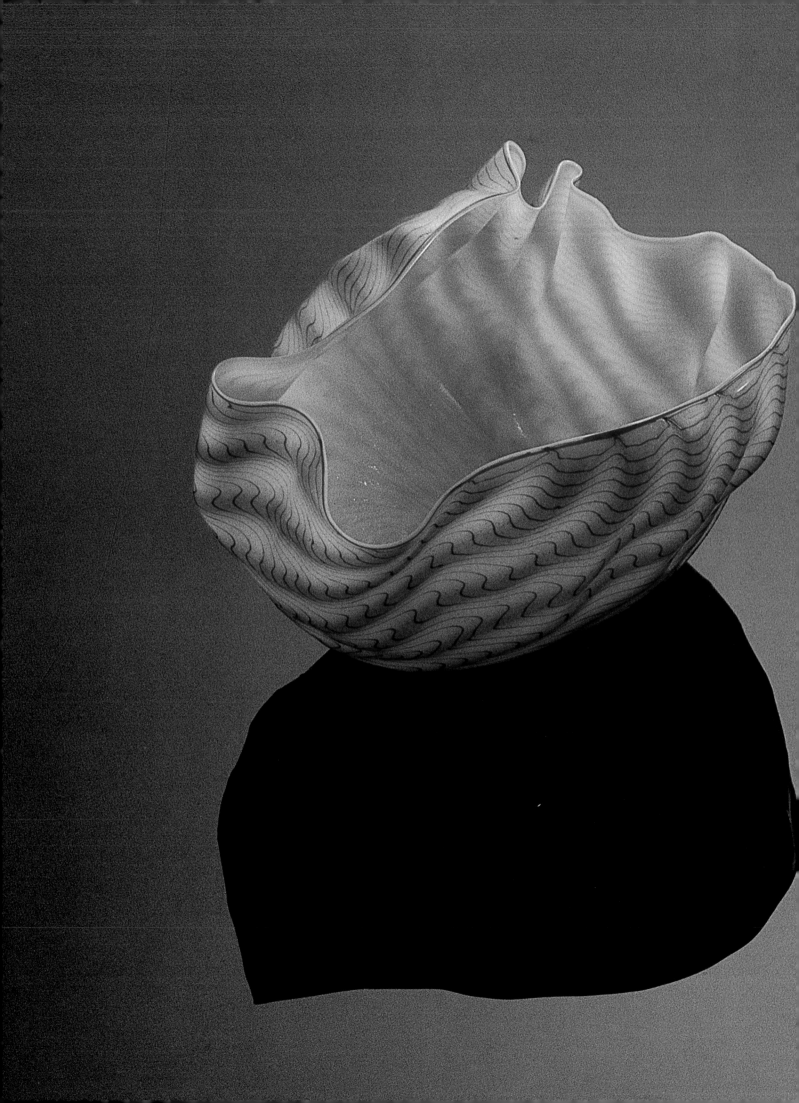

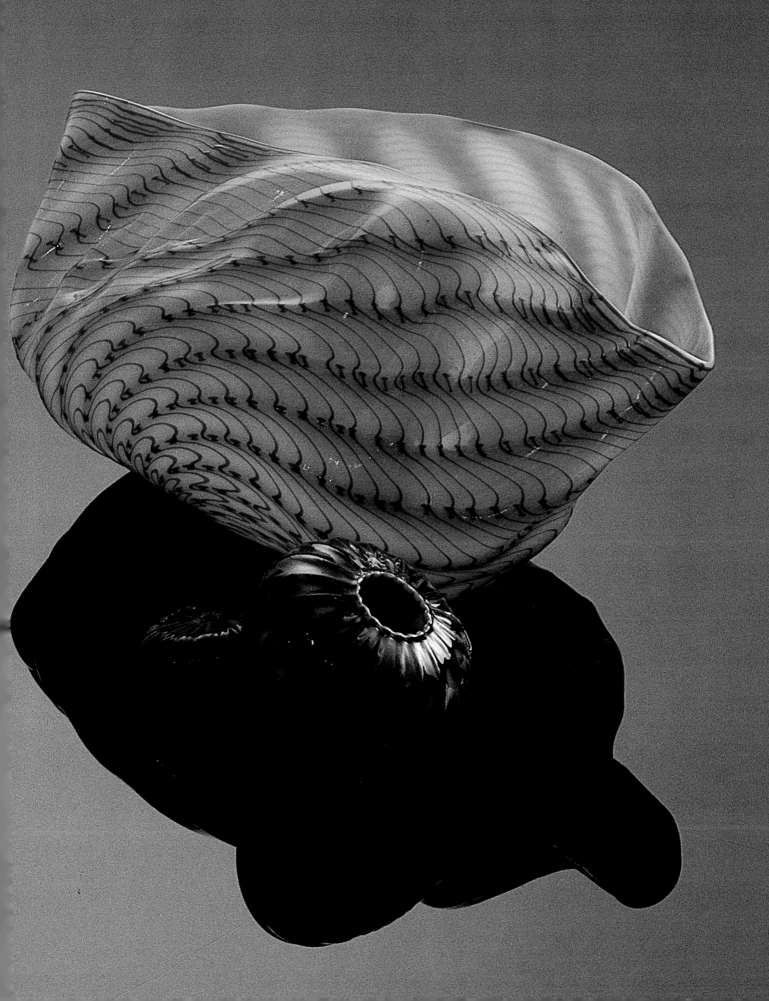

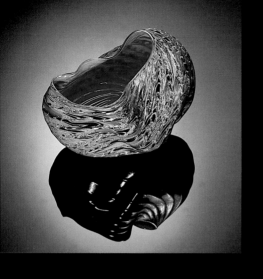

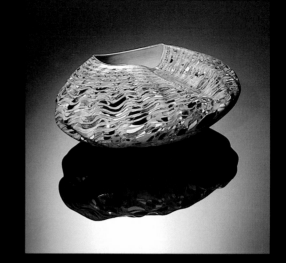

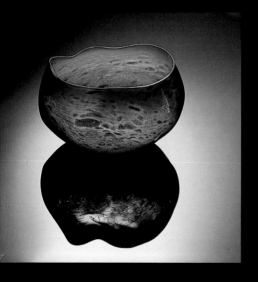

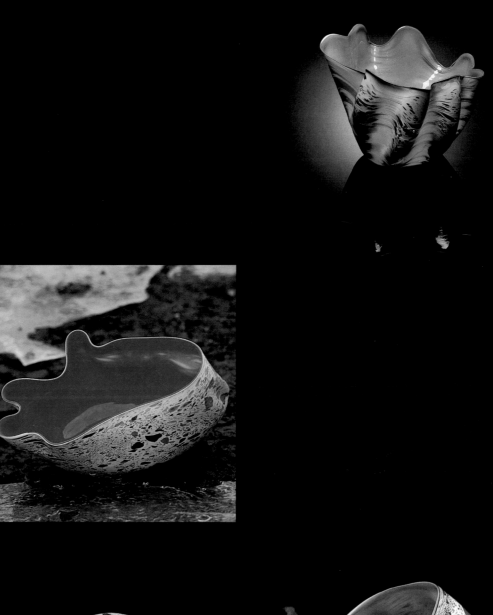

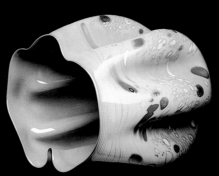

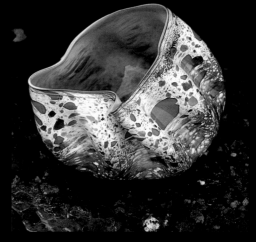

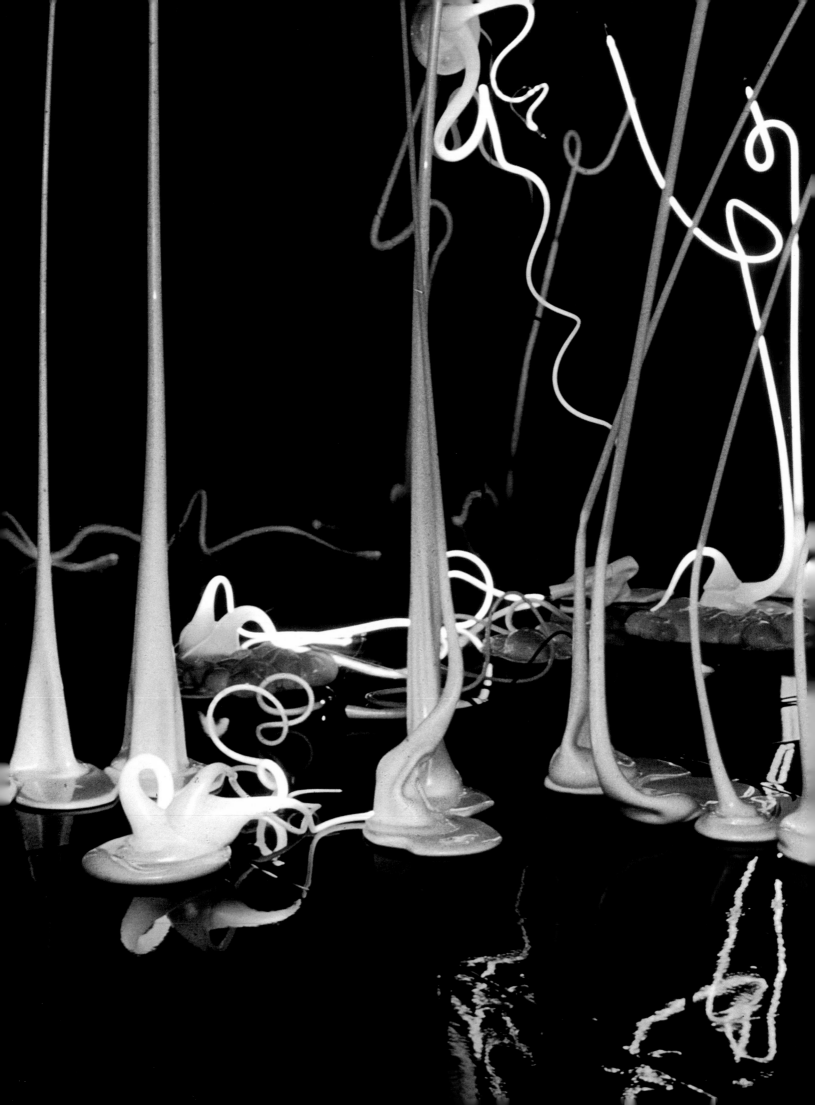

1941 Born September 20, in Tacoma, Washington.

1956-58 Attends Stadium High School in Tacoma. Works part-time at local meat-packing plant. His brother, George, is killed in an accident when Chihuly is 15; his father, George Chihuly, an international union organizer for meat cutters, dies the following year.

1959 Graduates from Wilson High School and enters University of Puget Sound, in Tacoma. Following year, transfers to University of Washington in Seattle.

1961-62 Leaves school and sails for Europe on the SS France. After touring extensively in Europe, travels to Israel, where he works on a kibbutz in the Negev Desert.

1963-64 Re-enters University of Washington in Interior Design and Architecture under Hope Foote and Warren Hill, but devotes much of his energy to weaving. Begins experimental work with glass, often fusing it into woven hangings for windows. Introduced to Jack Lenor Larsen by Hope Foote.

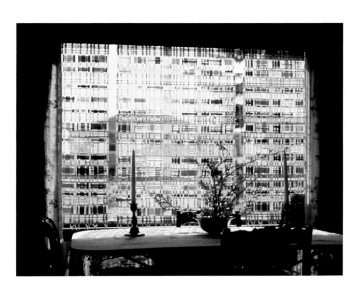

Glass Weaving, 1964. Early glass weaving for Viola Chihuly's dining room.

Again travels throughout Europe, visiting Leningrad and making the first of many trips to Ireland.

1965 Graduates from University of Washington with degree in Interior Design. Begins work as a designer for John Graham Architects in Seattle, but concentrates on experiments and projects in stained glass. Begins to blow glass on his own.

1966 In order to study glassblowing, abandons career as designer and works in Alaska as commercial fisherman to earn money for graduate school. Enrolls in M.F.A. program at University of Wisconsin, Madison, under a full scholarship, to study glassblowing with Harvey Littleton.

1967 Receives M.S. from University of Wisconsin and enters M.F.A. program at Rhode Island School of Design, Providence, where he is offered a teaching assistantship. Teaches glass courses and works primarily on large-scale environmental "glass rooms," often incorporating neon and other materials.

Meets Italo Scanga at a guest lecture given by the artist, beginning one of the most important artistic relationships in Chihuly's career.

One-man shows at Attica Gallery, Seattle, and University of Wisconsin Gallery, Madison.

1968 Graduates from Rhode Island School of Design with M.F.A., and continues environmental installations, using glass, neon, plastics, rubber, etc.

Receives Tiffany Foundation Grant for work in glass and a Fulbright Fellowship to study glass at the Venini Glass Factory on the island of Murano, Venice. Chihuly is first American glassblower to work at Venini.

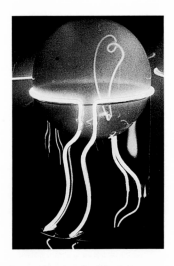

Lamp Design for Venini, 1968-69. Prototype for large-scale project.

1969 After working on models for large-scale neon and glass projects at Venini, leaves Venice and visits Erwin Eisch in Germany, the Libenskys in Czechoslovakia and then travels on to Ireland, where he spends the summer.

In late summer, returns to U.S. to teach at Haystack School, and in fall, begins to teach full-time at Rhode Island School of Design, serving as head of the Glass Department. Begins collaboration with student Jamie Carpenter.

Included in "Objects, U.S.A.," The Johnson Collection of Contemporary Crafts. (Traveling exhibition circulated by the National Collection of Fine Arts, Smithsonian Institution.)

1970 Teaches summer school at the University of California, Berkeley.

Collaborates with Carpenter on the "Haystack Red Series," at Haystack.

Develops plans for Pilchuck Glass Center, modeled on features he admires at both Haystack and the Rhode Island School of Design.

Included in "Young Americans," Museum of Contemporary Crafts, New York, and "Toledo Glass National III," a circulating exhibition organized by the Toledo Museum of Art.

1971 Important collaborative work with Carpenter, including:

—"20,000 Pounds of Neon and Ice," for Woods Gerry Gallery, Rhode Island School of Design.

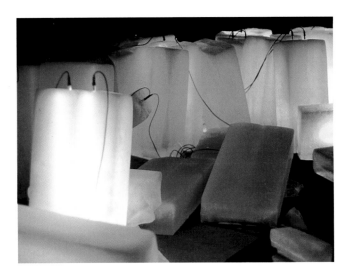

"20,000 Pounds of Neon and Ice," 1971.

Chihuly, Patrick Reyntiens, and Italo Scanga at Pilchuck.

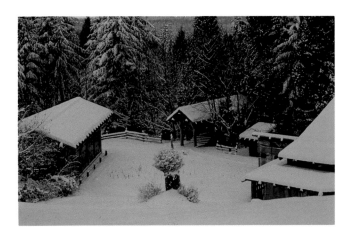

Pilchuck under snow.

—"Glass Environment," installed as two-man show "Carpenter and Chihuly," Museum of Contemporary Crafts, New York. (Later permanently installed at the Museum Bellerive, Zurich.)

Starts Pilchuck School on a tree farm north of Seattle with a $2000 grant from the Union of Independent Colleges of Art. The land and additional funds were donated by John Hauberg and Anne Gould Hauberg, friends of Jack Lenor Larsen.

Late that summer, teaches at the Penland School in the Blue Ridge Mountains of North Carolina.

Included in "First Invitational Hand-Blown Glass Exhibition," Tacoma Art Museum, Washington, and "Attitudes," Brooklyn Museum of Art, New York.

1972 Returns to Venice and works with Carpenter at Venini, preparing several pieces for "Glas Heute," an exhibition at the Museum Bellerive in Zurich. Experiments with techniques later employed in large architectural projects.

Spends summer and fall at Pilchuck where he begins using glass rods for greater color options. Completes first architectural project, with Carpenter, utilizing lead and blown glass, which is included in "American Glass Now," traveling to The Corning Museum of Glass; Museum of Art, Carnegie Institute, Pittsburgh; Museum of Contemporary Crafts, New York; Renwick Gallery, Smithsonian Institution, Washington, D.C.; San Francisco Museum of Art and Santa Barbara Museum of Art, California.

1974 Visits glass centers in Venice, Prague, Stockholm and Helsinki with Tom Buechner of The Corning Museum of Glass and Paul Schulze of Steuben Glass.

Teaches at Institute of American Indian Art, Santa Fe, where he builds a glass shop with students; also teaches a RISD summer course in stained glass on Block Island, Rhode Island.

Experiments with Carpenter, Kate Elliott, and Italo Scanga on new "glass drawing pick-up" techniques at Pilchuck. Further refined, this drawing technique will be used in the "Blanket Cylinders" of 1975 and 1976.

Works on the "Corning Glass Museum Window" (last project done with Carpenter), which was installed at Corning in December.

Glass Pick-up Drawing.

1975 "Glass in Architecture" interview with Chihuly and Carpenter, by Seaver Leslie, published in the *Bulletin of the Rhode Island School of Design.*

Develops "Blanket Cylinders" after seeing Navajo Blanket show at the Boston Museum of Fine Arts. Kate Elliott, and later Flora Mace, fabricate many of the glass drawings for the cylinders.

Helps start glass program at the University of Utah's Snowbird Art School, in the mountains outside Salt Lake City.

One-man exhibitions of "Blanket Cylinders" at Utah Museum of Fine Arts, Salt Lake City, and Institute of American Indian Art, Santa Fe.

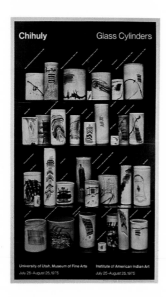

"Blanket Cylinders" poster designed by Malcolm Grear for 1975 museum shows.

Works at Pilchuck and Haystack and collaborates with Seaver Leslie on site project at Artpark in Lewiston, New York, in August.

Chihuly and Kate Elliott receive Master Craftsman-Apprenticeship Grant awarded by the National Endowment for the Arts; Chihuly also receives individual NEA grant.

1976 Collaborates with Seaver Leslie and Flora Mace on "Irish Cylinders" and then travels to Europe for lecture tour. Has serious car accident in England, en route to Ireland, losing sight in one eye.

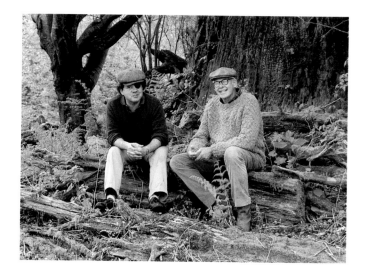

Dale Chihuly and John Hauberg, 1982.

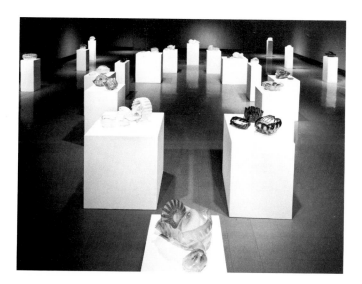

Installation, Tacoma Art Museum, 1981.

Recuperates at painter Peter Blake's country home and in early February returns to U.S. where he is cared for by Joan Wolcott for several months while he slowly readjusts to working. Accepts position as head of RISD Sculpture Department for the following year. Undergoes plastic surgery in June; then spends summer in Tacoma and at Pilchuck.

Studio Glass Magazine devotes entire issue to students and faculty of Rhode Island School of Design Glass Department.

One-man show, "Cylinders and Blankets," at Bell Gallery, Brown University, Providence, and one-man traveling exhibition circulated by Western Association of Art Museums.

Two-man show, with Michael Singer, at the Wadsworth Atheneum, Hartford.

Contacted by Henry Geldzahler, who purchases three cylinders for the permanent collection of The Metropolitan Museum of Art, New York.

1977 Abruptly stops series of "Blanket Cylinders" and begins the "Pilchuck Baskets"—inspired by the Northwest Coast Indian baskets seen at the Tacoma Historical Society in Washington.

"Baskets" arouse little interest when they are included in "Carpenter, Chihuly, and Scanga" at the Seattle Art Museum in Washington. Show is curated by Charles Cowles, who later becomes Chihuly's New York dealer.

One-man shows at Helen Drutt Gallery, Philadelphia, and Hadler/Rodriguez Gallery, Houston.

1978 Invited to show "Blanket Cylinders" at the Renwick Gallery, Washington, D.C.; adapted to include new work, show becomes "Baskets and Cylinders: Recent Work by Dale Chihuly."

Meets William Morris, then employed as a truck driver at Pilchuck, who begins assisting Chihuly.

Included in "Craft, Art, and Religion," an invitational show at the Vatican Museum, Rome.

First one-man shows at the Foster/White Gallery, Seattle, and Habatat Galleries, Detroit.

1979 Works in Baden, Austria with Ben Moore, William Morris, and Michael Scheiner; has one-man show at Lobmyer, Vienna.

Resigns post as head of Rhode Island School of Design Glass Department and assumes position as Artist-in-Residence; works actively at Pilchuck throughout summer and fall on "Pilchuck Baskets Series" and has one-man show, "Dale Chihuly/VIDRO," at Museo de Arta, São Paolo, Brazil.

Included in the important traveling exhibition "New Glass," organized by The Corning Museum of Glass and scheduled at The Metropolitan Museum of Art, New York; Victoria and Albert Museum, London; Musée des Arts Décoratifs, Paris, and other major museums.

1980 Spends summer and fall at Pilchuck before traveling to the Scilly Islands, off Cornwall, England. Chihuly then travels to Hamburg to show work at Rosenthal Studio Haus, and returns to Rhode Island School of Design in December.

One-man shows at Haaretz Museum, Tel Aviv ("Dale Chihuly, An American Artist"); Dart Gallery, Chicago; Fendrick Gallery, Washington, D.C.; Foster/White Gallery, and Habatat Galleries.

Completes large-scale windows for Shaare Emeth Synagogue in St. Louis, fabricated of acid-etched, handblown stained glass, with the assistance of Eric Hopkins and Eve Kaplan.

Interviewed by Vincent Tovell for the Canadian Broadcasting Corporation.

1981 Blows glass in Tucson in February and then begins projects in Austria with Ben Moore, Rich Royal, and Jeff Held. Has one-man shows at Lobmyer in Vienna and Rosenthal in Berlin.

Returns to Providence and works at Rhode Island School of Design preparing for first one-man show at Charles Cowles Gallery, New York, in April, where he exhibits fragile "Sea Forms." Has first one-man show at Betsy Rosenfield Gallery in Chicago.

Travels with William Morris to Edinburgh to visit Celtic expert Ricky de Marco and continues on to Orkney Islands in the North Sea to visit "Stone Circles."

Spends summer and fall working at Pilchuck, preparing one-man show in hometown at Tacoma Art Museum. Returns to Haystack School as Artist-in-Residence and in December, travels to São Paolo and Rio de Janeiro for exhibitions.

One-man shows held at Foster/White Gallery; Habatat Galleries; Clarke Benton Gallery, Santa Fe; and Hokin Galleries, Palm Beach.

Interviewed at Pilchuck by Barbaralee Diamonstein for ABC-TV.

1982 Works at numerous glassblowing facilities throughout the country, including Ohio State University, Illinois State University, Appalachian Center for Crafts, Rhode Island School of Design, Pilchuck Glass Center, and private studios in Tucson and Seattle.

Included in "Contemporary Glass: Australia, Canada, U.S.A.," National Museum of Modern Art, Kyoto, Japan, and "World Glass Now—'82," Hokkaido Museum of Modern Art, Sapporo, Japan.

A major one-man traveling exhibition is organized by Kate Elliott, to be shown at Phoenix Art Museum, Tucson Museum of Art, San Diego Museum of Art, and St. Louis Art Museum.

Selected Museum Collections

American Craft Museum, New York

Australian Arts Council, Sydney

Australian National Gallery, Canberra

The Corning Museum of Glass, Corning, New York

The Detroit Institute of Art, Michigan

The Fine Arts Museum of the South at Mobile, Alabama

Glasmuseum Frauenau, West Germany

Haaretz Museum, Tel Aviv, Israel

High Museum, Atlanta, Georgia

Johnson Wax Collection, Racine, Wisconsin

Kestner-Museum, Hannover, West Germany

Kunstgewerbemuseum, Berlin, West Germany

Lobmyer Museum, Vienna, Austria

Madison Art Center, Wisconsin

The Metropolitan Museum of Art, New York

Museum of Art, Rhode Island School of Design, Providence

Museum Bellerive, Zurich, Switzerland

Museum fur Kunst und Gewerbe, Hamburg, West Germany

National Museum of Art, Kyoto, Japan

Philadelphia Museum of Art, Pennsylvania

Phoenix Art Museum, Arizona

Seattle Art Museum, Washington

Tacoma Art Museum, Washington

Tucson Museum of Art, Arizona

University of Wisconsin, Madison

Utah Museum of Fine Arts, Salt Lake City

Kunstsammlungen der Veste Coberg, West Germany

Victoria and Albert Museum, London, England

Wadsworth Atheneum, Hartford, Connecticut

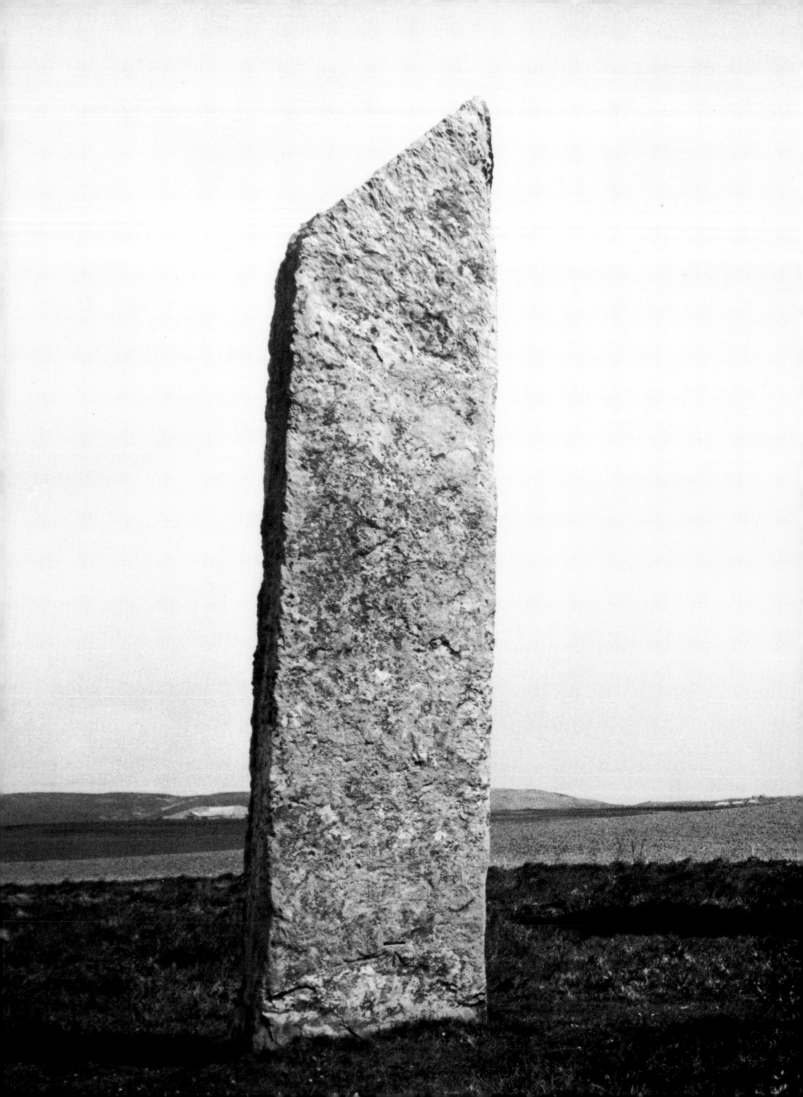

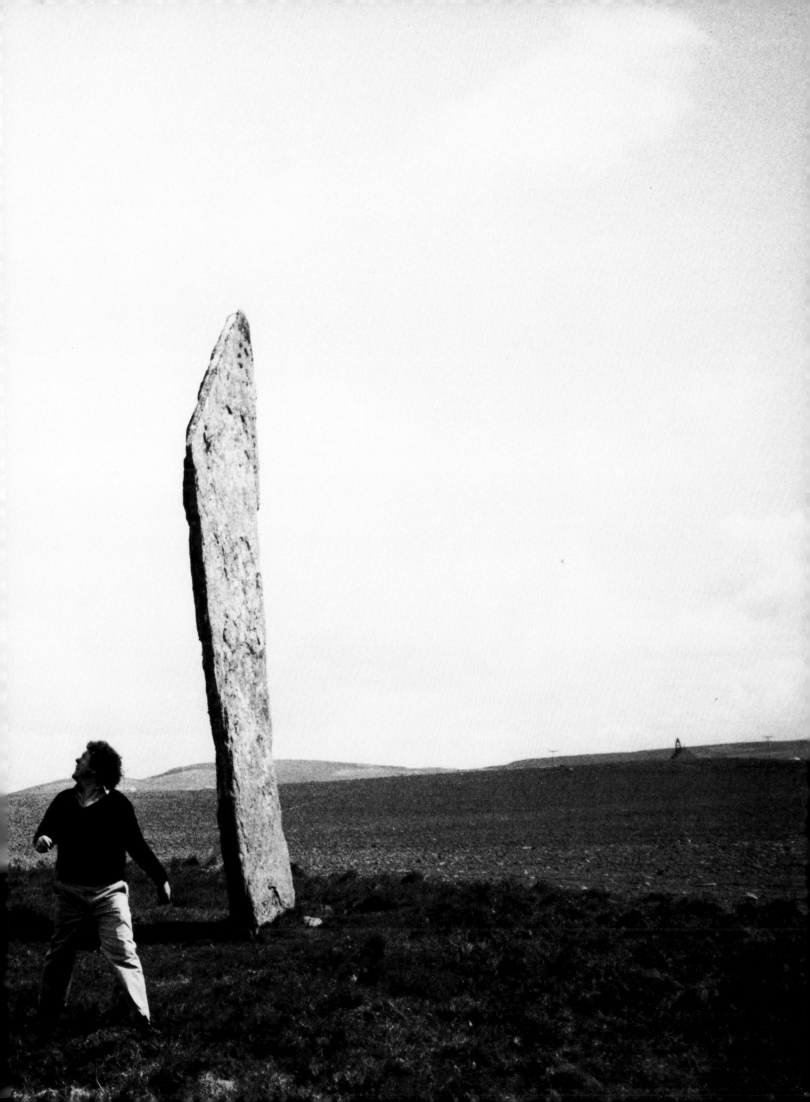

Photographic Credits